ABOUT THE AUTHOR

D. PRESTON SMITH MD, FACS, FAAP, FSPU
Pediatric Urologist

D. Preston Smith attended Rice University where he graduated with honors in Economics. He attended the University of Texas Medical School at Houston and following graduation he spent two years in General Surgery at the University of Tennessee Medical Center at Knoxville. In 1993, he finished his Urology Residency at Northwestern University in Chicago. He concluded his training upon completion of a two-year fellowship in Pediatric Urology at the University of Tennessee at Memphis and LeBonheur Children's Hospital in 1995. Dr. Smith is board certified and he has authored or co-authored many articles, papers, chapters, and books in Urology and Pediatric Urology. His research has been presented throughout the world.

Dr. Smith is married and is a father of three young children. He currently maintains a very busy pediatric urologic practice. He is a fellow of the American Academy of Pediatrics, American College of Surgeons, and Society of Pediatric Urology. His dedication to helping children with urologic problems inspired him to establish PottyMD. Dr. Smith hopes through PottyMD to aid thousands of children, families, and physicians by educating them about issues related to potty problems in children.

Helping kids to stop and to go.

PottyMD was established in 2003 by pediatric urologists to help parents and children with all types of potty issues. We are continually studying new methods to help children overcome their poor potty habits. We believe the products we offer are the best and most affordable available. PottyMD will continue to research new products and will make them available as they meet our standards.

PottyMD is dedicated to helping children overcome all bladder and bowel issues including:

- Potty training -Urinary tract infections
- Daytime accidents -Holding
- Bedwetting -Belly pains and cramps
- Constipation -Urinary frequency
- Encopresis -Holding

1-877-PottyMD pottymd.com

This book is dedicated to the many frustrated parents and families who lost hope of ever overcoming their child's bladder and bowel problems. I hope this book will shed the brightest light on these common problems and provide the tools needed to avoid unnecessary hardships in the future.

ACKNOWLEDGEMENTS

Many, many thanks are extended to the individuals who helped with the creation of this book--Kyla Melhorn RN, Karen Reed RN, Allison Dulaney, Dana Smith (my wife), and to Denise McClure (illustrator).

TABLE OF CONTENTS

FOREWORD

The increasing incidence of urinary and constipation problems in today's society is clear. Dr. Preston Smith's book is an excellent guide for parents and caretakers, as it provides a thorough understanding of how and why urinary and constipation problems develop. Dr. Smith, a fellowship-trained pediatric urologist, has spent an immense effort in creating this comprehensive book to educate parents about their child's problems. As I do in my practice, Dr. Smith expends vast efforts trying to convey to families that their child's urinary and constipation problems are related more to societal issues than to direct *medical* problems. I completely and emphatically agree with all of the explanations and guidelines that Dr. Smith outlines. He does a wonderful job explaining these problems in non-technical language, so that parents can be instrumental in solving their child's problems. I sincerely believe that if parents read this book carefully, they will come to truly understand why their child is having difficulty.

I cannot express too strongly that there is no "magic pill" for treating this problem; the program that Dr. Smith outlines is hard work for all of the family members involved. I sincerely hope that the information in this book will be disseminated nation-wide, not only for the benefit of the parents, but because some of these strategies ideally will be implemented in day cares, schools, and public restrooms. Although the child's primary aid will come from the parents, in order to alleviate the child's problems and prevent further problems from arising, we need to examine this issue in the social context in which it occurs.

I congratulate Dr. Smith on his immense effort in writing this important book. I am well aware that this labor of love was completed purely for educational purposes and for the children's benefit. This work took away from his own family time, and we are forever indebted to his wife and children for allowing him the time

to educate us so insightfully about the urinary and constipation problems running rampant in our society.

Sincerely,

Bradley P. Kropp, M.D., F.A.A.P.
Associate Professor
Chief of Pediatric Urology
Vice Chairman of the Department of Urology
University of Oklahoma Health Sciences Center

CHAPTER 1

INTRODUCTION

Just when you thought your child was potty trained you are faced with more pee and poop problems. Read this and I will teach you how to keep your child potty trained.

As a pediatric urologist and a father of three young children, I have considerable experience in both normal and abnormal potty habits. My profession as a pediatric urologist is intensively involved with a wide variety of issues relating to urinating and bowel movement functions. I have treated thousands of children with these kinds of problems. But, not until I was blessed with three wonderful children, did I become truly experienced in potty habits and managing urination and bowel movement problems. I used to wonder during the early years of my practice why "darn parents can't get their darn children to use the darn restroom." As a father, I now have sympathy. I am now able to incorporate my personal experiences with the education I have received to provide compassionate advice to others that are faced with a wide array of potty problems.

This handbook will discuss all of the aspects of urine and bowel problems in children. I will try to answer as many of the questions and concerns you may have regarding your child's problem. Since these problems are so common, I hope to provide you the tools that are needed to correct any bladder or bowel problem your child or patient may be experiencing. I am proud to say, that during our research, we have not found a similar book anywhere that addresses childhood urine and bowel problems in a comprehensive, parent friendly and practical way. I truly hope that in reading this book, a troubled parent or practitioner can glean some useful advice and understanding when "helping children to stop and to go."

I have wanted to write this book for some time now. I hope your enthusiasm for what you are about to read equals what I have experienced while creating it. If this book can help the lives of children with urine and stool problems and avoid unnecessary medical treatments and problems from occurring, then it has served it purpose.

> **The information in this book does not constitute medical advice. You should contact your doctor if you should have any medical concerns or want medical advice.**

CHAPTER 2

HOW CAN THIS BOOK HELP MY CHILD AND ME?

Good potty habits will improve hygiene issues, avoid embarrassment, limit parent frustration, save money, and prevent unnecessary medical testing and procedures.

If children can develop bladder and bowel habits, their lives will be improved. They can be spared the embarrassments that are associated with accidents and avoid the frustrations of having to use the restroom frequently. Playtime and learning time will be better. Avoiding significant belly pain, constipation and urinary tract infections will prevent unnecessary visits to the pediatrician, family doctor and specialists. This in turn, will prevent unnecessary blood work, x-rays and invasive testing. Some of the tests are painful, traumatic, and embarrassing. Anesthesia may be required for some invasive testing in children with urinary symptoms, unexplained belly pain, or constipation. Blood tests, x-rays, and procedures may find abnormalities that are not significant, which may lead to an inaccurate diagnosis or further unnecessary evaluations. Constipation may be treated with suppositories or enemas, which are also traumatic and embarrassing.

Good urine and stool habits can avoid unnecessary medical testing, expense, and childhood hardship.

Millions of children have difficulties with daytime urine habits, bedwetting, and constipation. Normal urine and stool functions after potty training are expected, yet so many children develop problems. The focus of this book is not on potty training, but on problems that occur after training. If you are a parent, grandparent, or care provider that is facing these difficult issues, this book will be

your best resource. This book will educate you on how to establish good urine and stool habits in your child on a day to day basis. A concise, practical, and loving "program" is outlined. This book includes comprehensive discussions about the various treatment options, diets, and tools that are necessary to overcome abnormal potty habits.

CHAPTER 3

WHAT I BELIEVE

There are probably more children now with abnormal potty habits than ever before. I believe there are several explanations why more children are affected with bladder and bowel problems that extend beyond the simple fact that there are more children in the world. Lifestyles for children and their parents are becoming more busy and complex. These lifestyles are less likely to allow for the time and parental involvement that are required for many children to develop good bathroom habits. Children now have activities that are more focused and regimented than in the past. TV and computer games are current day examples of mesmerizing activities that can distract a child from using the bathroom and prevent them from taking their time when they do go. Pressures to keep an active social life have certainly not diminished. Children are more commonly enrolled in school activities, sports, extended care, and the like, which may not provide the best environment for monitoring and encouraging good potty habits. These "distractions" may explain why some children develop potty habit problems.

Simple conveniences such as diapers and wet wipes have also allowed us to be more disconnected from potty issues. Modern diapers, pull-ups, and wet wipes are so good at absorbing urine and concealing stool that abnormal potty habits are often ignored or masked until an older age when it becomes a socially significant issue. By this time, abnormal urine and stool habits are going to be harder to correct. The best time to start enforcing good urine and stool habits is during potty training.

Physicians and parents tend to be too narrowly focused, when attempting to treat a child with urine or stool problems. For example, it is not common knowledge that urine and stool

problems are commonly linked. If you solely work on the urinary problem without considering the bowel movements you are likely to fail (and vice versa). Many times a urine or stool problem will escalate if not addressed from several different angles. As the problem escalates, it may require more intensive treatment. The current advice parents are receiving does not address potty habits as a collection of issues that need to be considered. As a result, treatments for various bladder and bowel problems are usually ineffective because they are too narrow and focused.

> **Dealing with childhood pee and poop problems requires an open mind to all of the non-obvious factors that may explain or provide for the best treatment.**

CHAPTER 4

PEDIATRIC AND FAMILY PHYSICIANS ARE IMPORTANT

Prior to committing energies on changing your child's potty habits, your child should be evaluated by a physician. Your child may have a medical condition that easily explains why she is having problems using the restroom. Physical and mental conditions must be considered prior to embarking on a path of realigning potty habits. Warning signs of a possible medical problem include: urinary tract infections, inability to potty train, walking difficulties, and developmental delays to name a few. A referral to a urologist or gastroenterologist may be necessary for expert advice regarding potty habit issues. If your child's physician does not feel there is a significant medical explanation for the cause of the potty problems, then it is reasonable to proceed with the suggestions in this book. Please consult a physician if there is any doubt.

CHAPTER 5

WHICH KINDS OF CHILDREN HAVE PROBLEMS?

All types of children at different ages can have problems with their potty habits. Different personality types, lifestyles, and parenting styles can contribute to potty problems. Some children may have problems immediately after potty training. Others may not have problems for years, and then later develop significant difficulties. Some children openly discuss and exhibit their difficulties; while others are unaware they are having problems. In the past, it was customary to believe that the "difficult children" who were abused, less fortunate, mentally challenged, and obstinent were the ones with the potty problems. Now, we realize, any child can have confusion and difficulty establishing good potty habits. In other words, parents should not feel alone if their child is having difficulties. If a child has extra distractions, excitements, depressions, and attention deficits, then these may contribute. There are too many childhood factors to list that influence potty habits, but a few of these include: peer pressures, lifestyles, intelligence, parental involvement, divorce, school issues, personality traits, and psychological states. Even children who are seemingly well adjusted, and are under no additional stresses, may need help with urine and stool problems.

The famous neuropsychologist, Dr. Sigmund Freud, provided a classic description of a normal personality and lifestyle type that commonly develops urine and bowel related problems. These people who over-exercise their pelvic muscles and sphincters are called "anal-retentive." The anal retentive personality is very common, and is often referred to as having a Type-A personality. This personality type and lifestyle is commonly seen in persons who are intense, focused and have high energy. Anal-retentive people (and children) tend to be at the extreme ends of the emotional

21

spectrum. They are usually so concerned and focused on multiple issues; they tend to hold their urine/stool without even realizing it. As a result, these intense (and usually bright and motivated) individuals are usually constipated and have problems with bladder functions. It is my belief that family histories of bedwetting, bladder problems, irritable bowel, or urinary tract infections are most likely explained by inherited or acquired family personalities and lifestyles and not necessarily an inherited physical problem. As stated before, personalities and lifestyles must be considered as factors that affect potty habits.

CHAPTER 6

TODAY'S CHILDHOOD AFFECTS POTTY HABITS

In this chapter you will be introduced to the following factors that may explain why children have different bathroom habits:	
Disposable diapers	Potty Training
Family dynamics	Child personality
Activities	Distractions
Hygiene	Bathroom Access
Parenting Styles	Bathroom Fears

Raising a child today is very different than in the past. Current issues related to child rearing may contribute to the development of abnormal potty habits. For starters, diapers are significantly improved from what they were in the past. Prior to disposable diapers, cloth diapers were the only game in town. Cloth diapers were hypoallergenic and environmentally friendly, but they did not absorb well and required significant parental involvement. They needed to be pinned, washed frequently, and monitored closely for leaks and blowouts. The children needed to be watched closely and their diapers required frequent changing. Cloth diapers were not usually thrown away, but were often bleached, washed, and dried. Odor was always a concern. Diaper rashes and raw bottoms were commonplace. The best way to avoid these problems was to change the cloth diapers often. Ready supplies of clean diapers, powders, and ointments were needed to avoid problems.

The new diapers parents have at their disposal (pun intended) have alleviated a lot of the problems that were associated with the cloth diapers. The newest generation diapers are less likely to leak and they are very absorbent. They are discarded after each use and

diaper rashes are less common. The newer disposable diapers allow parents more freedom from their child's urine and bowel movements. As a result, parents are less aware of their child's urine and stool frequency, volume and consistency. Disposable diapers have caused parents to become more removed from analyzing and understanding what is taking place with their child's potty habits. An interesting study showed that in the 1950's more than 90% of children were potty trained by 18 months of age; now less than 10% are potty trained by 2 years of age. Advanced diaper technology may explain part of this change. The newer generation diapers have made our lives easier, yet we have lost some of the fundamental understanding of our own child's bodily functions. Since children begin to develop urine and stool habits with during potty training it is important to be aware of problems early and for parents to stay involved in their child's potty habits. Parents and physicians commonly treat potty training and potty problems after training as completely different subjects, when in fact, there are many significant overlapping issues.

Family dynamics and childhood lifestyles can contribute to the development of abnormal potty habits. Family dynamics and childhood lifestyles are changing. There are more working mothers and single parents now than in the past. This usually leaves no one person in charge of attending to the child's bathroom habits. Children may receive mixed signals from daycare workers, babysitters and teachers that do not share the same goals or expectations. Children's schedules that are more fragmented and hurried will often lead to a disorganized approach to using the bathroom. Parents that are not always present are less able to assess the problems and are forced to rely on others to provide this information. Because they are not always with their children, working parents usually have more difficulty with punishing or structuring abnormal bathroom behavior. Divorce, new homes, new schools, and new siblings are some of the significant changes in a child's life that can also affect potty behavior. Do not underestimate the psychological impact that may occur on a child

when their home life is disrupted and their daily routine is fragmented. Psychosocial issues have been shown to be some of the most influential factors that affect a child's potty habits.

Modern day games and activities are clearly more focused and intense than they have been in the past. Children's games and toys used to be more basic and group-oriented. Children were more likely to stop what they were doing in order to eat, visit, and use the restroom. Television and hi-tech activities are now much more prevalent. Children become focused on the TV and are hesitant to leave an exciting program to use the restroom. Computers and computer games are usually a one-person activity and will often mesmerize the child for long periods of time. Hand held games are taken everywhere and kids are hesitant to place them down to take a potty break. If they use the restroom they may lose their place in the game, or worse, another child or sibling may take the game and not give it back. Televisions, computers, and computer games are becoming more affordable and available. These activities are obstacles in the way of using the potty. It is very common for parents to tell me the story that their child would completely ignore them, and everything around them (including the bathroom), while they were watching the television, using the computer or playing a computer game. If I had my way, every child with urine and stool problems would have very limited access to these distractions until they exhibited significant improvement.

Children are very involved in many types of activities. There are many types of activities for children of all ages. There tends to be more social pressures for children to be involved in sports, musical instruments and activities. Organized sporting activities and after school programs currently allow for less neighborhood play. While it is important for children to have exposure to as many opportunities as possible, social pressures and hectic lifestyles may result in them being overextended. Instead of having a home nucleus around which many of these activities take place, families are now carpooling and going places in a hurried fashion that does not promote a healthy approach to using the restroom. Children are commonly being told to 'hold it', 'wait until we get there', or to 'hurry up because we will be late.' A very busy lifestyle during childhood can be detrimental to establishing good bathroom habits and correcting potty habit problems when they occur.

Parents are more aware of the psychological influences they have on their children. Psychologists have emphasized child rights, autonomy, and self-development in recent years. While most people agree with many of these concepts, the roles teachers, parents, and guardians have in providing structure and strict guidance has been

de-emphasized. Parents and other caregivers may be hesitant to be firm with a child, since this may be misconstrued by some to be restrictive or detrimental to child development. When it comes to formulating and establishing good potty habits in young children, especially shortly after potty training, consistent and strict parameters for using the restroom need to be established. I often remind parents about the importance of "tough love." I tell them, "Because you love your child, you may need to be firm with the potty habits."

Parents have become more concerned with dirty restrooms and toilets ever since transmitted diseases have been more widely discussed in our communities. When HIV and AIDS became an epidemic, many parents became concerned about diseases that could be contracted in the bathroom and on the toilet. Bathrooms were thought to harbor deadly diseases and parents began to discourage children from using public restrooms. Sexually transmitted diseases and other communicable diseases have also gained widespread media coverage. Either consciously or subconsciously, this has resulted in people being less willing to use public facilities. Even when the public restrooms are used, the children are less relaxed and hurried because their grownups are more focused on hygiene and expedient use.

Children do not always have easy access to a restroom. Public restrooms are not places where parents and teachers want their children to hang out. Parents have become more concerned about kidnappings, child molesters and unsafe encounters—issues that are common day occurrences. Parents do not want their children out of sight, and they view the restroom as a potentially unsafe environment. Children, therefore, have less freedom to use restrooms by themselves. Public restrooms can be more crowded and dirtier, which further discourages their use. Schools and teachers are not very understanding about the importance of good potty habits, and they limit bathroom access for younger children because of safety concerns. Teachers are typically responsible for

too many students to allow frequent and unhurried restroom visits for each child. The school restrooms are considered "gross" by the older children, because they are commonly laden with graffiti, do not have toilet tissue, and do not have doors on the stalls. As a result, older children do not commonly use the restrooms at school.

CHAPTER 7

UNDERSTANDING NORMAL POTTY HABITS

HOW THE BLADDER AND BOWEL WORK TOGETHER

Newborns have reflex emptying of their bladder and bowel. In other words, when the bladder or rectum fills, they empty. There is probably not much thought involved, and it is more of a spastic or reflex emptying. That is why there are frequent wet and full diapers in babies. Their diet of formula and breast milk also contributes significantly to frequent bowel movements. As the infant becomes a toddler their diet changes and their bowel movements become more bulky. They are also beginning to understand their bodily functions and start to experiment with holding their urine and stool. Natural growth and holding both urine and stool will result in stretching the bladder and large intestine (colon). As a result, the capacity to hold more is increased and the intervals between emptying their bladder and bowel becomes even longer.

Toddlers may also avoid urinating or having a bowel movement so that they do not have to have their diapers changed (I believe young children are smarter than we realize). Diaper rashes may become painful, especially when they come in contact with urine and stool. For this reason, diaper rashes may cause a child to hold their urine or stool longer, especially if they think that wet wipes, washings and even ointment application will be painful. Although not the focus of this book, potty training is highly individualized and can rarely occur as early as one year of age. Psychologists tend to think that toddlers hold their pee and poop because of control issues, since these are two of the very few things they can control. I am sure there are some valid and subtle psychological explanations for why some children have control issues and hold their urine and stool but

it is not practical to explore these issues in this book. Quite frankly, regardless of any psychological explanations, the potty problems still need to be addressed. Knowing that children less than two possess the intelligence of experimenting with holding their urine and bowel for extended periods of time, parents should realize that holding issues can and often do transfer into the post-potty training era.

Once children experiment with potty training they learn several processes that can lead to establishing normal bladder and bowel functions. In order to store urine, the bladder relaxes much like a balloon and holds relatively large volumes of urine under low pressure. The pressure in the bladder does not start to increase significantly until it gets near capacity. While the bladder is storing urine, the sphincter muscles that wrap around the urethra like a doughnut are tight so that urine does not leak. There are two sphincter muscles, one that we cannot tighten or control and one that we can tighten and control if we desire. When one tightens their pelvic or bottom muscles, they are contracting one of these sphincters. When the bladder gets full, there is an urge to pee. By contracting one of the sphincters, the urge can be suppressed, which allows more time to get to the restroom. When we go potty, we relax the tightened sphincter muscles and go.

SIDE VIEW

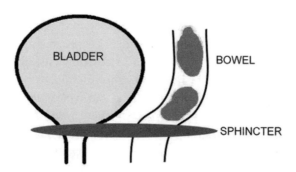

Bowel movements are similar, but they sometimes require straining to move the stool into the rectal area (lower intestine). Then with some relaxation and dilation of the anus (the last inch of intestine)

the flow of stool occurs. The pelvic muscles that control the sphincters must be relaxed to effectively empty both urine and stool. When we are almost finished using the potty, we intermittently contract and relax our pelvic and sphincter muscles, and the bladder and lower bowel will empty any left over urine or stool. When we completely finish, the pelvic muscles and sphincters will reestablish the tone that will be needed to once again store urine and stool.

This normal process is a very effective way to empty and store pee and poop. The best any of us are at voiding is when we are having a bowel movement—we pee and poop and then pee and poop again until empty. In summary, as the bladder stores urine, the sphincter muscles are tight, and when we decide to pee, we then relax the pelvic muscles and the bladder contracts and pushes the urine out. This is similar, but not exactly the same, with bowel movements (see illustrations).

BLADDER STORING URINE

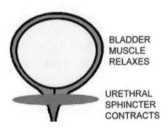

BLADDER MUSCLE RELAXES

URETHRAL SPHINCTER CONTRACTS

NORMAL BLADDER EMPTYING

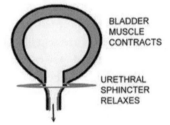

BLADDER MUSCLE CONTRACTS

URETHRAL SPHINCTER RELAXES

BOWEL STORING STOOL

NORMAL STOOL EMPTYING

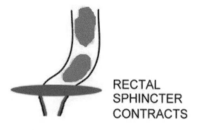

RECTAL
SPHINCTER
CONTRACTS

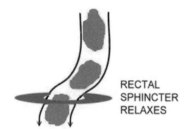

RECTAL
SPHINCTER
RELAXES

Just as some individuals are born with big feet or long arms, some children are born with large bladders and bowels (intestines). A child that is born with a larger bladder or colon (large intestine) does not necessarily mean that it was stretched or that it is abnormal. Studies have shown that children with bigger bladders have fewer problems with bedwetting and urinary frequency. However, a large bladder may be harder for a child to empty, or it may allow the child to avoid using the restroom for longer periods of time. If the colon is large (dilated), then less frequent bowel movements or constipation may occur. The differences in bladder or bowel size are usually not significant, but they must be taken into account when trying to explain the different potty problems children experience.

With an understanding of what normally occurs with urine and bowel movements it is easier to correct problems in children when they occur.

WHAT IS NORMAL DIGESTION AND ELIMINATION?

Now that we better understand the normal development of urine and bowel functions in childhood, let us discuss what specifically happens with the digestive system and the process of having a bowel movement. The gastrointestinal tract (GI tract) is divided into four distinct parts: the esophagus, stomach, small intestine, and large intestine (colon). Each of these segments, or parts, has a separate function. The esophagus is the tube connecting the throat to the stomach. Its primary function is to push and move food and liquid into the stomach for digestion. The stomach then makes acid and substances that break down the food into nutrients the body can absorb. The small intestines are the next segment. It takes broken down and partially digested food and liquid and either absorbs the nutrients or further digests the food. The small intestine absorbs some fluid and water but the majority of water absorption takes place in the large intestine (colon).

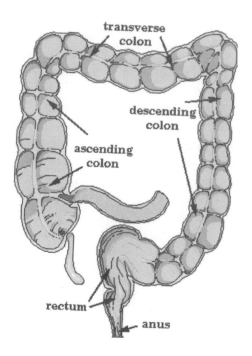

Specifically, the large intestine (colon) absorbs excess water from digested food while it is forming stool (waste product). If a child has had a recent illness that caused him to be dehydrated or drink fewer fluids, then the colon will absorb more water from the stool to make up for the recent fluid losses. Muscle contractions (peristalsis) push the waste towards the rectum. This may require some straining, but usually the colon contractions will move the stool. It is at this time the urge to have a bowel movement usually occurs. Once the stool reaches the rectum, it is solid because most of the digestion has taken place and the water has been absorbed. With time and relaxation, the anus dilates and allows the flow of stool. The pelvic muscles that control the sphincters of the rectum and anus must be relaxed to effectively empty the stool. When finished, the pelvic muscles or sphincters will intermittently contract and relax and allow any remaining stool in the lower colon to empty. When completely finished, the pelvic muscles and sphincters will reestablish the tone that will be required to once again store stool.

Some of the processes involved with having a bowel movement are involuntary, and others happen with the child being aware. For example, as stool is accumulating in the colon the child is not usually aware of how full it is becoming. Also, children are unaware the colon contractions are moving the stool towards the rectum. These contractions are constantly at work and unless these contractions are strong (cramps) there are no sensations to realize what is happening. When having a bowel movement, a child has sensations associated with and is aware of three steps that are occurring. These include:

- The colon pushes stool into the rectal area which causes pressure
- Child has an urge to have a bowel movement
- The child must relax the external anal sphincter to eliminate the stool

There are steps that a child can control in the processes of having bowel movements. First, a child does control the diet. If a diet rich in fiber and fluids is consumed, then bowel movements will be more regular. Foods that cause constipation can also be consumed in excess. Second, the urge to go can be suppressed by ignoring the body messages and refusing to go to the restroom. Finally, if a strong urge to have a bowel movement occurs, a child can contract the bottom muscles (sphincters) and avoid going for a longer period of time. This can result in stretching the colon and prolonging the need to go.

The number and frequency of normal bowel movements in children varies by age. Usually younger children have more frequent bowel movements than older children. This, of course, depends on diet and fluid intake. Diet and fluid intake will be discussed in more detail later, but the more fiber and fluid a child consumes, the more frequent the bowel movements become. Infants can have variable movements depending on whether they are breast-fed or formula-fed. Infants generally have several movements a day or go two to three days before having a stool. A young child (less than five years) usually has at least one stool a day. Some may have even two-three a day. Others may have one bowel movement every second or third day. As long as a child does not develop any potty problems or pain, then the number and frequency of stools may not be important. Older children, usually those from six to eighteen, will have less frequent stools. This is most likely due to lifestyles, diet, natural growth and stretching of the large intestine. Once again, as long as the child does not develop any problems, then the schedule of bowel movements may not be an issue.

CHAPTER 8

WHAT ARE ABNORMAL POTTY HABITS?

Abnormal potty habits are anything your child does with their urine or stool that causes problems. Children may develop problems that last a few days, several months, or even years. If your child has any of the following, then abnormal potty habits should be considered.

Urinates often (frequency)
Holds urine for long periods of time
Urinates quickly (urgency)
Wiggles or squats to avoid urinating (pee pee dance)
Does not take time in the restroom (pit stops)
Difficulty urinating (hesitancy) or straining to urinate
Daytime accidents (incontinence)
Bedwetting (nocturnal enuresis)
Urinary tract infections (UTIs)
Blood in the urine (hematuria)
Belly pain
Constipation
Bowel movement accidents (encopresis)
Anal problems (hemorrhoids and fissures)
Stained underwear
Slow or difficult to potty train

Abnormal potty habits present at all ages and in a wide variety of ways. Urinary frequency may develop shortly after potty training or later in childhood. Some children will have sudden urges to go one day and be normal the next day. Daytime accidents may suddenly develop with no apparent explanation and bowel changes may occur slowly and silently over time. Bedwetting may appear as an isolated problem or be associated with other less obvious daytime bladder or bowel problems. Since childhood bladder and bowel problems do not always fit a typical pattern, parents and physicians

can become easily concerned by problems like abdominal pains, urinary tract infections, constipation, blood in the urine, and genital discomforts. Many of the abnormal potty habits may even change with time—making it harder to understand what is taking place. With a "watchful eye" many of these common problems can be overcome by simply making children "learn to stop and to go."

Most parents can identify several items from the list above that describe their child's potty habits. If any of these abnormal potty habit problems are affecting the day-to-day life of your child, then they should be addressed. Most children do not develop abnormal urine or bowel habits intentionally, and they should not be punished for having these problems. It is the responsibility of the parents to change their child's potty habits through a loving and structured approach that will result in a happier and healthier child.

CHAPTER 9

COMMON CHILDHOOD URINE PROBLEMS

In this chapter we discuss in more detail some of the more common childhood urinary problems. Examples and details are provided for the following problems:

Urinary Frequency	Urinary Urgency
Daytime Accidents	Difficulty Going
Urine Holding	Urinary Tract Infections
Vesicoureteral Reflux	Blood in the Urine
Bedwetting	Bothersome Privates

URINARY FREQUENCY

Urinary frequency in children is very common. Urinary frequency may be intermittent and severe. Frequency occurs more commonly during times of excitement and distress. It can also occur at times when everything is presumably stable. Some people refer to urinary frequency as having a "nervous bladder" or an "overactive bladder." Frequency is most likely to occur in children who are not willing to relax, take their time and completely empty their bladder. As a race fan, I commonly refer to these children's bathroom visits as "pit stops." Children are so excited about other activities like playing, reading, socializing, watching TV and playing computer games, that they try to hold their urine as long as possible and avoid using the restroom by tightening their pelvic muscles and sphincters. They will commonly wiggle, dance and squat to avoid using the restroom. When they finally go, it is usually urgent, and they do not take their time in the restroom. They do not relax and let all of the urine out. The bladder may feel empty to the child, but it still contains urine.

A child does not have to be in a hurry to not empty their bladder. If a child is extremely distracted and unable to relax their sphincter muscles, they may only urinate small amounts and leave a significant amount of urine behind. A bladder that is not completely empty takes less time to become full and will need to be emptied more often. Therefore, urinary frequency is very easily explained in children with abnormal potty habits. . I recall one of my children having intermittent episodes of severe urinary frequency. It was not until I had my child relax and take extra time in the restroom that I started to see significant improvements. On several occasions, she told me that after spending more time on the potty, more urine came out, and it surprised her. I, of course, praised her since this meant she was probably empty.

Unfortunately, the only way to easily convince a parent or care provider that a child is not empty is to perform a bladder ultrasound or insert a catheter (plastic tube) into the bladder after the child has urinated. These methods provide an accurate measurement of how much urine is left behind. Pediatric urologists commonly use ultrasound to see if a child empties, because it is less invasive than a catheter.

Young children are usually good drinkers. They will drink frequently, taking in small amounts, usually with sippy cups and parental incentives. Children with urinary frequency and other voiding problems do not need to be encouraged to drink more fluids. This may only cause them to make more urine, but it will not promote better bladder emptying. Consuming extra liquids may cause a child to be more resistant to use the restroom, since they already think they are spending too much time there to begin with.

Drinks that contain carbonation and caffeine are thought to be irritating to the lining of the bladder or prevent the sphincter from relaxing. As a result, these drinks may cause a child to urinate frequently. Drinks that have significant sugar can cause increased urine production, and will also cause a child to use the restroom

more often. Caffeine and sugars are stimulants, and give children unneeded energy that will prevent them from relaxing on the toilet when necessary. Carbonated drinks, caffeinated drinks, and those containing large amounts of sugar should be avoided in children with abnormal potty habits. However, in my opinion, urinary frequency is most commonly caused by incomplete bladder emptying and not necessarily by the type or amount of drink a child consumes.

URINARY URGENCY

Urinary urgency is extremely common in children of all ages. This problem usually becomes very obvious to others when a child suddenly squirms, squats and wiggles, and demands quick access to the bathroom.

Having to urinate urgently can happen at inopportune times; when you are in the car, shopping, or in the middle of some other activity in which quick availability of a restroom is not always present. In

the past, parents were encouraged to tell their children to hold it and to try to not use the restroom. It was thought that this would stretch the bladder, and give them more time before needing to use the restroom. Recently, pediatric urologists have discouraged the practice of having children avoid using the restroom. In essence, having a child postpone using the restroom is asking them to tighten their pelvic muscles much like a woman performs Kegel exercises. Then, when the child is able to go to the bathroom they are less likely to be able to relax the strengthened pelvic muscles (sphincters), and allow all of the urine to be emptied from the bladder. Furthermore, tightening these pelvic muscles when the bladder is full is only going to cause the bladder to have spasms and contractions. Remember, the bladder is a muscle, and if it attempts to empty against a tight sphincter, then it will thicken and become stronger. As a result, it will be more forceful and quick with its attempts to empty, thereby, causing urgency. A thickened bladder may become normal and thinner once a routine is established, and it no longer needs to fight against a tightened sphincter muscle. The bladder is only trying to do its job of telling the child it is full and needs to be emptied. When children experience urinary urgency they usually have waited too long, and should have used the restroom earlier, prior to it becoming an emergency.

ABNORMAL BLADDER EMPTYING

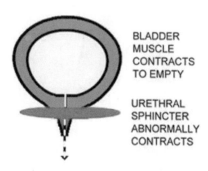

BLADDER
MUSCLE
CONTRACTS
TO EMPTY

URETHRAL
SPHINCTER
ABNORMALLY
CONTRACTS

Younger children do not understand the importance of urinating often and taking their time. This is why parents should be discouraged from asking their child "do you need to use the restroom" or "can you go potty now." Many children, especially those newly potty trained, do not know the sensation of a full bladder until it is extremely full or too late. Requesting or demanding that a child use the potty often will alleviate episodes of urgency. It is difficult to constantly remind your child to use the restroom, but it is very important. Parents should recruit as much help as possible from grandparents, babysitters, teachers and other care providers to make sure their child goes to potty often--at least every two hours.

DAYTIME ACCIDENTS

Daytime urinary accidents (incontinence) are a frustrating and socially embarrassing problem that deserves considerable attention. Leaking of urine can start at an early age, shortly after potty training, and continue throughout childhood. Young children who experience daytime wetting usually will say they had absolutely no warning and no idea that they were going to wet. Although these children do not intentionally lie, I believe they usually have some warning. In most cases, these children waited too long before using the restroom, and the bladder had a sudden urge to empty. Young children are often very involved and focused on the tasks at hand and ignore the subtle body messages that tell them their bladder is getting full and it is time to use the restroom. Warning signs usually include grabbing their privates, squirming and having episodes of belly pain. If they ignore these or even temporarily contract some of their pelvic and sphincter muscles, they are able to procrastinate and wait longer. They will continue to play or participate in their current activities without having to use the restroom. Eventually this will catch up to them, and they will leak. By the time they consciously realize that they need to go, it is too late.

43

It is my belief that children do not understand why they have an accident, and therefore do not learn from their mistakes. Instead they probably tell themselves 'the next time I will run faster to the restroom' or 'I will hold my bottom muscles (sphincter) tighter next time.' These responses further instill bad potty habits. The treatment is to not allow young children to determine when they need to use the restroom. Once again requesting or even demanding that a child use the restroom on command at frequent intervals will alleviate this problem. The child is probably not at fault and scolding and punishment should be avoided. Parents, teachers and caregivers who do not understand the issues may be contributing to the problem by punishing or encouraging children to wait and use the restroom at a later time. As the child grows and their self-awareness of bodily function improves, the wetting accidents diminish. The bladder size also increases, which allows longer intervals between bathroom breaks.

Urinary incontinence is also common in older children. Adolescents and teenagers, especially girls, will complain of leaking when they giggle or laugh or just after urinating. Giggle incontinence refers to episodes when the child wets with laughing, coughing or activities. This is most likely a child's form of stress urinary incontinence that is commonly seen in older women. Laughing, coughing and physical activity cause the abdominal muscles to tighten and place pressure on the bladder. If the bladder is usually kept full and the sphincter muscles temporarily relax, then accidental wetting in small amounts may occur. By history, these children tend to be holders of their urine, which also causes the bladder to thicken. A thickened or muscular bladder occurs because it is constantly trying to empty, while a child resists and tries to hold urine for long periods of time. A full and thickened bladder is more likely to contract or have spasms and cause leakage when one laughs, coughs or lifts heavy objects. A pit stop or a non-relaxed bathroom visit is most likely the culprit when a child experiences a small amount of leakage just after using the restroom. The best treatment for these leakage problems

in older children is to once again instruct them to have frequent and relaxed bathroom habits.

Diapers, pull-ups, padded underwear, and incontinence pads should only be used for isolated situations, since they will allow the child not to address the issues that are required of them. Parents and children should be encouraged to treat the problem, not just hide the leakage. All children with the various forms of urinary leakage, no matter how large or small, need to know that their abnormal bathroom habits need to be corrected.

DIFFICULTY GOING POTTY

Children with abnormal potty habits can experience episodes of being unable to start a urinary stream (hesitancy). Feeling the urge but being unable to pee can be extremely frustrating for both children and their parents. This happens to children of all ages. The ability to pee on command is not always an easy task. Children who are so intent on trying to hold urine during the school day or during fun or intense activities are exercising their pelvic muscles/sphincters, thereby causing themselves to have more difficulty relaxing these strong muscles/sphincters when needing to urinate. If a child is preoccupied with other thoughts or in a hurry and unable to relax, then it is more difficult to start a stream of urine. Children who are unable to urinate will easily give up and attempt to potty at a later time.

45

Parents are frequently guilty (I have done this myself) of standing in the bathroom coaching their child while running the water and requesting that they urinate. Many parents will read books and play games in order to get their child to stay on the potty longer. Parent coaching, playing and running water are probable distractions and should be avoided. Placing the child in the restroom by themselves, instructing them to relax (do not strain, do not grunt, do not push) and telling them you will return in a few minutes is the best way to teach them how to relax and empty.

Children who have difficulty starting a stream (hesitancy) should be discouraged from giving up or trying too hard. If they become easily frustrated or learn to strain and push, the problem will only get worse. If your child can learn to sit and relax on the potty she will eventually learn the task of relaxing her pelvic muscles and letting the urine out. Children with urinary hesitancy should be instructed to sit down, whether boy or girl, with their bottoms deep into the toilet seat and spread their legs apart and relax. If this does not work, then closing their eyes and taking deep breaths may help. I call this "potty yoga". It is also acceptable to have your child sit backwards on the commode and lean against the back. Children with this problem should remain on the commode for several minutes in a comfortable and quiet manner. They should also be discouraged from taking games, books and toys into the restroom, as this will only further distract them from learning their normal bodily functions.

POTTY YOGA

Difficulty initiating a bowel movement is a similar problem. Children will state that they need to go, but then come out of the restroom and say that they couldn't. More than likely, if they had the sensation to begin with, they probably did need to go. If your child complains of difficulty of having a bowel movement, but his stools are not hard, large or painful then simply encouraging him to

relax and take his time may give positive results. If hard, large or painful stools are an issue, then constipation treatment with mild laxatives, a bowel program, and a good diet is needed to help correct the problem.

URINE HOLDERS

Children that use the restroom infrequently without having accidents probably have larger bladders and do not usually present with this as a complaint or problem. However, the infrequent visits to the restroom may eventually cause significant problems in these children. They can develop belly pain because their bladders remain full. If they don't pee often, urinary tract infections and accidents, to name a few, can result. A child who develops significant belly pain, urinary infections, or other problems will require medical treatment. This in turn may cause the child to undergo unnecessary testing, x-rays and procedures in order to determine the cause of the problem. It is sometimes only after exhausting, costly and invasive testing that it becomes apparent that the child is either not urinating often and/or has constipation—both of which can be easily treated.

URINARY TRACT INFECTIONS

If a child does not frequently empty her bladder, she is more likely to get urinary tract infections. Abnormal potty habits are the most common cause of urinary tract infections in children. Even with good hygiene, girls are more prone to infections than boys. Girls have a shorter urethra (the tube that drains urine from the bladder) that is close to the rectum and allows bacteria to more easily enter the bladder and vagina. Bladder infections usually present with burning, frequency, urgency and incontinence. Bladder infections (cystitis) are problematic, but they usually do not cause significant damage to the kidneys or bladder. Kidney infections (pyelonephritis), on the other hand, usually present with fever, back pain, nausea, and fatigue. Infections involving the kidney can cause

damage or scarring to the kidney, especially if multiple infections occur. Urinary tract infections warrant an evaluation and treatment by a physician. Kidney and bladder tests and x-rays are usually performed in children with urinary tract infections. Abnormalities or birth defects of the bladder, ureter (kidney tube) or kidney may be discovered with these tests.

VESICOURETERAL REFLUX

Vesicoureteral reflux (when urine backs up from the bladder to the kidney) may be diagnosed when a bladder x-ray is obtained. In order to diagnose vesicoureteral reflux, a catheter (tube) is inserted into the urethra and the bladder is filled with dye and an x-ray is taken. Reflux is a clinically significant problem in children who have had urinary tract infections with fever (pyelonephritis), abnormal kidneys, or abnormal kidney function. Vesicoureteral reflux may be accidentally or incidentally discovered when bladder x-rays are performed in children with abnormal potty habits who do not have urinary infections or other kidney problems. Vesicoureteral reflux usually warrants a consultation with a pediatric urologist to determine if medical or surgical treatment is necessary.

In my opinion, reflux and other mild abnormalities of the kidneys and bladder are over diagnosed and over treated in some children with potty problems. Since abnormal potty habits are the most likely cause for urinary tract infections without fever, it may be excessive to initially investigate for reflux in these children. Children whose abnormal potty habits caused a simple urinary tract infection can be subjected to unnecessary x-rays, long-term antibiotic use, or even surgery if reflux is incidentally discovered. Even if reflux is present, improving the child's potty habits should be a primary focus of treatment. Vesicoureteral reflux may correct itself in time, especially with better urine and bowel habits.

It is our goal to avoid unnecessary treatment and testing by establishing good potty habits before a urinary tract infection develops.

48

BLOOD IN THE URINE

Straining to pee, stretching the bladder and forceful urination can cause irritations to the bladder and urethral linings. This can in turn cause blood in the urine that is not always visible to the naked eye. The blood that cannot be seen may be discovered in the urine when examined by a physician. Irritations around the urethral opening that are caused by excessive wiping, urinary leakage, and rashes can also cause blood cells to be seen in the urine test. If a primary care physician notices blood or blood cells in your child's urine, then further testing and x-rays may be performed to rule out other problems. Frequent and complete emptying of the bladder without over stretching, good local hygiene, and avoidance of irritation to the private parts can avoid potentially unnecessary medical treatment.

BEDWETTING

Bedwetting is very common. Despite considerable research and spent monies, a single cause has not been discovered. The same treatment options for bedwetting have been used for many years, and these have only provided moderate success. Bedwetting, or nocturnal enuresis as it is officially called, is most likely caused by several factors which make its treatment more difficult. Before I propose my suspicions about another potential cause of bedwetting and how it can be better treated, I will provide a brief overview of current theories.

Small bladder size is thought to be associated with bedwetting. Certainly if one has a small bladder, then he will need to use the restroom more often during the day and at night. During the day one can more easily deal with a small bladder and avoid having an accident by simply going to the potty. A small bladder that fills during sleeping hours will try to empty, and if the child does not wake up, this will result in bedwetting. Since there are no medications that significantly increase bladder size, children with larger bladders more easily respond to bedwetting treatments.

Deep sleep is another potential cause for nocturnal enuresis, and it is the basis by which many bedwetting alarms have been sold. Most children are deep sleepers, and there has not been a convincing medical study that exhibits sleeping disorders to be more prevalent in children who bed wet except for those who stop breathing for short periods of time during sleep (sleep apnea). It is not easy nor is it safe to change the depth of sleep in children for the purpose of stopping nighttime wetting. Most children who bed wet are deep sleepers, but most deep sleepers are not bedwetters.

Bedwetting alarms are recommended when deep sleep is considered to be a primary cause for nighttime wetting. Bedwetting alarms are triggered to alarm when they come in contact with urine. This process attempts to awaken the children and their families when the wetting occurs in hopes it will 'condition' the child to awaken prior to wetting in the future. This conditioning is effective when the parents and child consistently work with the alarm over a period of time. The alarms can be awkward, and many times they will initially wake up the parents without waking up the child. Over a period of days or weeks most children will learn to awaken prior to being wet. A wide variety of bedwetting alarms exist. The two main types of alarms include: 1) a small alarm sensor is positioned in the underwear or pull-up and connects or communicates with a shoulder or bedside alarm or 2) a larger pad that serves as a sensor is placed under the child and on top of the bed which connects or communicates with a bedside alarm. Some alarms make noise and some vibrate. They are moderately expensive, but they are safe. Bed alarms are most successful when the parents are prepared to use them for several weeks or months.

Drinks with sugar, caffeine and carbonation have been implicated as contributing to bedwetting. These types of drinks are not considered healthy and should be limited in children regardless of a bedwetting problem. To say that these drinks are responsible for bedwetting is far-fetched. Drinking large amounts of any liquids

prior to going to bed is strongly discouraged in children with a bedwetting problem. Drinks of any type should be stopped at least 2 hours before bedtime.

Some studies have shown that bedwetting is associated with the increased production of urine during sleep. Increased nighttime urine production is the basis by which the drug desmopressin (DDAVP®) is used to correct bedwetting. Although this medication is mostly safe, it is associated with a few possible side effects. Recently it has been made available in a pill form (it used to be only available as a nose spray that required refrigeration). The results with DDAVP® are unpredictable, with some children getting excellent results and others getting no results. Children with larger bladders are more likely to have positive results when taking DDAVP®. Since it has not been shown that all children with bedwetting make too much urine at night, the results with this medication are mixed.

Psychological issues have also been shown to be more common in children who wet at night. Children under significant stress or experiencing psychological problems are more prone to be bedwetters. The reasons for this are probably due to several factors. Children with psychological problems tend to have altered sleep patterns and abnormal daytime potty habits which may affect their ability to be dry at night. The same personality types and lifestyles that lend one to have daytime bladder and bowel problems are more common in children with nocturnal enuresis. High energy individuals and those with psychological stressors not only have abnormal bladder/bowel functions, but they are also more likely to be deep sleepers since they use sleeptime to regain much of the energies that were used during the day. Parents of children with emotional instability and stressors should seek professional counseling for the child. This may help with many aspects of their lives including bedwetting.

I believe that abnormal daytime urine and stool habits are common causes for bedwetting. My view of bedwetting is different than what has traditionally been followed. Nighttime wetting has traditionally been viewed as a problem that occurs during sleep and has little to do with anything that occurs during the daytime. Certainly there are children with good daytime potty habits that wet at night, but I believe bedwetting is more common in children who have problems holding and have abnormal urine and stool habits during the day. Studies are starting to support what I have believed all along. Daytime urine accidents and constipation have been shown to be more common in children with bedwetting.

My experience has been that most children who bed wet also have issues with using the potty during the day. Since children are able to run to the restroom and tighten their sphincter muscles while they are awake, they can usually avoid having an accident. The same legs that run to the bathroom and the same sphincter muscles that are tightened to avoid having an accident during the day, go to sleep with the child during the nighttime. Therefore, children who do not completely empty during the day are most likely not empty when they pee just prior to going to bed. They think they are empty, but they are not. A partially empty bladder will more quickly fill up during sleep. Children with abnormal emptying during the day are likely to have bladders that are stronger or spastic, which are more likely to empty at night. Therefore, a full and spastic bladder is more likely to empty during sleep in children with abnormal potty habits during the day. This concept is difficult for parents to accept, especially if their child does not wet during the day. If a child has some daytime urgency, frequency, holding, leakage, or constipation, then these should be corrected prior to attempting other bedwetting treatments.

I strongly believe that bedwetting is caused by several factors and not by any single abnormality. I also believe that no one treatment works best for all children. Since rarely do I encounter a child who has absolutely no daytime bladder/bowel symptoms and only

nighttime wetting, I usually recommend working on any daytime potty problems that may be present. When offering advice to children and parents about how to overcome bedwetting, I try to explain that there is no "magic treatment" or "magic pill." I tell them their options include: (1) work on daytime potty habits, (2) try a bedwetting alarm, (3) try the medications (4) restrict nighttime fluids (5) offer rewards and praise or (6) a combination of the above. I also stress that treatment is not necessary since bedwetting usually corrects itself eventually.

Each of these treatments has advantages and they can be tried together. If the child is under significant stress, counseling should be considered. In most cases, it is helpful to cut back on drink consumption two hours prior to going to bed. Parents should be reminded that it is not the accident is not the child's fault, but that the child should help with changing and cleaning the wet clothes and bed sheets. Diapers and pull-ups should be avoided whenever possible. Some form of a reward system is helpful, especially for the younger children. Children do respond well to positive feedback, and praise and rewards do help. Hugs and kisses are probably the best, but other gifts and recognitions are additional incentives. It is usually my strong advice to parents to work hard on the daytime potty habits since it is harmless, inexpensive, and in my experience very successful if done correctly. Families who try the medications or the bed alarms without addressing the other issues are probably doomed to fail since bedwetting is caused by a combination of several problems.

> If a child has some daytime urgency, frequency, holding, leakage, or constipation, then these should be corrected prior to attempting other bedwetting treatments.

BOTHERSOME PRIVATES

Children with potty habit issues commonly describe discomforts or pain in their genitals (privates). Rashes and raw surfaces due to

moisture and wiping are obvious causes for some of these complaints. Not only do raw skin surfaces burn, but also the salts in the urine can be very irritating to these areas. Fewer accidents and less moisture from improved potty habits will help to alleviate this. Air, along with a topical salve (petroleum jelly, zinc oxide) will also help. Bladder/rectal spasms or sudden urges to pee or poop may also send sensations into the private areas and cause non-specific pains. Better potty habits will help the child to avoid holding, which in turn, may improve these pains. If a child with some potty habit problems presents to me with vague complaints of itching, pain, stinging, burning etc. in their private areas, but her exam is completely normal, then I assume she is having symptoms related to her potty habits.

CHAPTER 10

COMMON CHILDHOOD BOWEL PROBLEMS

CONSTIPATION

SIGNS AND SYMPTOMS OF CONSTIPATION

Constipation is not defined by how many or how often bowel movements occur. One can have a bowel movement a day and still be constipated. Conversely, having a stool every other day may not constitute constipation. Depending on your child's age and diet, the frequency of the stools may vary. In an attempt to better define normal versus abnormal stools, the Bristol Stool Scale has been devised.

THE BRISTOL STOOL FORM SCALE		
Type 1		Separate hard lumps, like nuts
Type 2		Sausage-like, but lumpy
Type 3		Like a sausage but with cracks in the surface
Type 4		Like a sausage or snake, smooth and soft
Type 5		Soft blobs with clear-cut edges
Type 6		Fluffy pieces with ragged edges, a mushy stool
Type 7		Watery, no solid pieces

There are, however, multiple clues to look for to determine if your child is constipated. Early intervention is essential to quickly resolve the problem and to avoid further difficulties. Some of the typical signs and symptoms are as follows:

- Frequent abdominal pain, cramping
- Painful bowel movements
- Hard or large stools
- Encopresis (bowel accidents and soiling)
- Bleeding with bowel movements
- Itchy or painful anus including hemorrhoids
- Smearing and staining of stool on underwear
- Irritable and disagreeable moods
- Gets full quickly when eating (described as being nibblers/grazers)
- Increased flatulence (gassy)
- Intermittent diarrhea and hard stools
- Recurrent attacks of nausea and vomiting
- Urinary frequency and urgency
- Urinary tract infections, bedwetting, urinary accidents and difficulty starting a stream

Severe constipation in a newborn should be evaluated by a physician. Infants and toddlers that exhibit constipation may continue to have problems after potty training. Shortly after potty training is a common time for children to become constipated from 'holding'. If others comment about your child's bowel movements, then you should monitor them closely and act accordingly. Be on the look out for constipation, even at a young age. Children that enter school will commonly develop constipation because they refuse to have a bowel movement at school. Also, schools will not always allow enough time between classes for your child to poop. If your child has stained underwear, it may mean your child does not wipe well, but it may also imply your child is constipated. Diarrhea may even be a sign of constipation, because only the very loose

stools upstream are able to go around the hard stools downstream. If your child is having urinary problems then it is very common for him/her to also have bowel problems (potty habit problems). Constipation that goes unnoticed is harder to treat and may cause more problems in the future.

CAUSES OF CONSTIPATION

Constipation is classified into two general categories based on whether or not there is an underlying medical or 'organic' cause. The vast majority (> 90 percent) of childhood constipation is not due to medical causes, but instead, caused by abnormal holding and diet. Simply said, children cause their constipation problems from being afraid, confused, or stubborn with their potty habits, and by having an unbalanced diet. This is both reassuring and frustrating for parents, since there is not usually a significant underlying medical problem to explain the constipation.

However, children with severe and long-term (chronic) constipation from holding can develop other significant medical issues. For example, if a child becomes so constipated that it results in a fecal impaction (inability to have a bowel movement), she can require hospitalization for enemas and bowel cleansing. The impaction is also associated with abdominal distention and pain that may require further testing to make sure other medical problems do not exist.

Non-Medical Causes

Non-medical causes for constipation deserve considerable discussion, since they are the most common and problematic reasons for constipation. There are several reasons why children develop constipation that are not due to medical causes:

1. Diet low in fiber and natural sugars
2. Diet high in constipating foods
3. Abnormal potty training
4. Abnormal potty habits=Holding
5. Past experiences--painful or difficult BMs

6. Constipating medications
 - Pain medication
 - Cold medication
 - Bladder/Bowel spasm medication
 - Iron-containing vitamins
7. Developmental delays/problems
 - Attention deficit disorders
 - Hyperactive disorders
 - Mentally delays
 - Abuse
8. Family history of slower bowel function

As infants change their diet from breast milk to formula or formula to cow's milk, they tend to develop harder and larger stools. This can result in painful or difficult bowel movements. Anal tears (anal fissures) and bleeding can occur at any stage, including the infancy. Diaper rashes can also make wiping and having a bowel movement more painful. Since these very young children are probably smarter than we think, they might hold their stools to avoid any discomforts and skin irritations.

The same is true with toddlers. As their diet changes further to solid foods and foods that are more constipating, they can develop stools that are hard or painful to pass. They too will hold to avoid this discomfort. In their immature minds, they probably think they can hold for a significant amount of time without any consequences. However, holding will only make the problem worse and prolong the constipation. Toddlers are also aware that their parents will change their diaper if it is dirty. This forces children to interrupt their fun activities, so they try to hold to avoid a diaper change.

Inconsistent, incomplete, or difficult potty training experiences can lead to abstinent behavior or confusion, which then can lead to constipation. Older children can develop bowel problems due to all

the above reasons, but they also begin to be more active and attend school. They have many fun and exciting activities (TV, sporting events, and computer games) that cause them to avoid using the restroom. Their holding and refusing to go can cause their colon to stretch and hold more stool. As a result, they lose the normal sensations to go. When they do go, it is urgent and they may have an accident if they do not get to the restroom quickly enough. In an attempt to avoid having an accident, they tighten their bottom muscles (sphincters). Over time, these muscles become stronger and harder to relax with each bowel movement. The child then runs the risk of not letting the entire bowel movement out, leaving more stools to accumulate and cause more problems.

These children commonly become very confused about the normal process of passing a bowel movement. They strain and are unable to completely relax their bottom muscles (sphincters). They may start to fear that it is going to hurt or take too long. Schools and teachers may also prevent these children from having frequent and unhurried visits to the restroom. They may hold until they come home, and by this time the urge may have subsided or the stool may be harder to pass. This confused state continues until they are guided to having normal bowel movements on a regular basis.

Adolescents and teenagers have many social issues and psychological pressures that may cause them to avoid using the restroom often. Like others, their diet also plays a significant role in having irregular bowel movements. These children typically eat foods that are not rich in fiber. They do not usually drink enough fluids that are required to prevent hard-formed stools. However, the most likely causes for teenage constipation include having constipation throughout childhood (it may have gone unnoticed) and holding because of social issues. At this age, children are very self-conscious and unwilling to go at school or in public restrooms. Middle and high schools have more restricted access to the restrooms. Furthermore, the stall doors may be missing, toilet paper may not be available and unfriendly ridicule by other students may

discourage them from having bowel movements at school. Teenagers can also be disgusted by 'dirty' public restrooms and they feel more comfortable going at home. Slowly and methodically, their constipation problem escalates and they start to develop vague belly pains and difficulty using the restroom. They might develop anal tears or hemorrhoids that make having a bowel movement more painful. Medical help might be delayed because of their reluctance to discuss their problem with anyone, including their parents.

The Most Common Causes of "Holding"
1. Diaper rashes
2. Avoid diaper changes
3. Pain associated with large, hard stools
4. Confusion regarding the normal bowel movement process
5. Not wanting to feel 'dirty'
6. Avoid having an accident
7. Avoid missing fun activities
8. School and social pressures
9. Busy lifestyle
10. Fear of public bathrooms

Any of these conditions can cause a child to develop large, hard and painful bowel movements. Hard and large stools can tear the anus and result in bleeding, itching and pain. This in turn can scare a child into not wanting to have a bowel movement. As a result of holding, the intestine absorbs more water from the stool making the stool even harder to pass. Large stools can also slowly stretch the colon to the point that the normal sensations to go are no longer evident. As a result, children do not get the normal urge to go often and continue to have further problems. Since parents are not always aware of their child's bowel functions, constipation can go unnoticed until it becomes a severe problem. Because infants have a wide variety of normal stools, it is even difficult for pediatricians and family doctors to determine when a significant problem is arising. Once constipation is considered to be an issue, non-medical

causes should be considered first before investigating for the infrequent medical causes that could exist.

Medical Causes

There are several medical conditions that can cause a child to develop significant constipation. Any deformity or past surgery of the digestive tract can, of course, lead to constipation. Most commonly, these birth defects and surgeries lead to loose stools, but constipation can occur. Any deformity or surgery of the nervous system (brain, spine and peripheral nerves) can also cause constipation. Pelvic surgery or radiation that disrupts the normal nerve functions of the bladder/bowel can commonly affect the ability to have a normal stool. The child's doctors and parents are usually well aware of the possible problems associated with these conditions, and they are usually prepared to treat them. Since these conditions are usually very complex and not part of normal childhood development, they will not be discussed further in this book.

A few other medical causes for childhood constipation do exist and merit discussion. These conditions may go undiagnosed for some time because the affected child may not exhibit any other obvious medical problems. These relatively rare causes for childhood constipation include Hirschsprung's disease, cystic fibrosis, and hypothyroidism.

Hirschsprung's Disease

In the normally functioning intestine, muscles push stool to the anus where it can leave the body. Special nerve cells in the intestine, called ganglion cells, provide the stimulus for the muscles to push the stool. A person with Hirschsprung's Disease does not have these nerve cells present in the lower part of the colon or rectum. The stool is pushed through the intestine until it reaches the region without the nerve cells. At this point, the stool can no longer be moved towards the anus easily. This causes the stool to 'hang up' in the colon, which causes constipation. The constipation can be severe and longstanding until treatment is provided.

Signs and Symptoms of HD include:
- Delayed first bowel movement in newborns
- Swollen abdomen and vomiting
- Constipation since birth
- Slow growth and development
- Anemia

The cause of Hirschsprung's Disease is unknown, but most children with HD have severe problems with constipation. Your child's doctor can perform certain tests to determine if your child suffers from Hirschsprung's Disease.

Treatment varies depending on the degree of symptoms and illness. Surgical intervention is usually necessary. You and your doctor will be able to decide on the appropriate treatment for your child once a diagnosis is made.

Cystic Fibrosis

Cystic fibrosis is a chronic, genetic disease of the body's mucous glands. Cystic Fibrosis primarily affects the respiratory and digestive systems in children and young adults.

In children with cystic fibrosis, the basic problem is an abnormality in the glands which produce or secrete sweat and mucous. Sweat cools the body; and mucous lubricates the respiratory, digestive, and reproductive systems. Sweat and mucous prevent the tissues from drying out and protects them from infection. Mucous is usually very thick in children with cystic fibrosis and it can accumulate in the intestines and lungs. The result is malnutrition, poor growth, frequent respiratory infections, breathing difficulties and eventually permanent lung damage. Your child's doctor will be able to make this diagnosis and recommend the most appropriate treatment.

The digestive problems in children with cystic fibrosis are usually less serious and more easily managed than the respiratory problems. A well-balanced, high-calorie and fiber-rich diet that is low in fat

and high in protein and pancreatic enzymes (which helps digestion) is recommended. Laxatives, enemas and mucolytic agents (chemicals that dissolve mucous) are sometimes needed to treat severe constipation and fecal impactions.

Hypothyroidism

Hypothyroidism is a condition in which the body lacks sufficient thyroid hormone. The main purpose of the thyroid hormone is to balance the body's metabolism. People with this condition have symptoms associated with a slow metabolism.

HYPOTHYROIDISM Signs and Symptoms
• Fatigue
• Weakness
• Weight gain
• Coarse, dry hair
• Dry, rough pale skin
• Hair loss
• Muscle cramps
• Constipation
• Irritability

There are several causes of hypothyroidism. If any of these symptoms are present, then a complete medical work up by a physician is suggested. Treatment of the symptoms and taking hormone replacement may be needed. The constipation treatment is similar to other children with constipation.

TREATMENT AND PREVENTION OF CONSTIPATION
1. Improve diet and fluid intake
2. Exercise
3. Avoid constipating medications
4. Improve daily/routine potty habits (pee and poop)
5. Initial bowel clean-out with laxative/enema
6. Low-dose daily medication/laxative
7. Open and loving discussion
8. Alleviate fear
9. Increased parental involvement
10. Rewards and praise

11. Counseling
12. Biofeedback
13. Monitor for recurrent constipation

There are several effective treatment options for constipation. Your child's physician will probably have a preference for a particular treatment. Parents will need to make sure the chosen program meets their child's needs. The best treatment depends on the child's circumstance, degree of fecal retention, and compliance to prescribed therapy. The best management for constipation is based on two basic principles: Empty the rectum; and keep it empty.

When deciding on the best management approach for your child's constipation, you should consider several important factors. You will need to keep in mind your child's age, lifestyle, degree of constipation, duration of problems and medical concerns. A younger child may require a more delicate medical management. It may be more difficult to make an older child be compliant with long-term treatment. A busy or hectic lifestyle will be harder to change and to make the constant changes that are required. The more severe the constipation or the longer it has been a problem, the more aggressive the treatment will need to be. Also, the longer your child has had a problem the longer he will need to stay with the program. If your child has other medical problems or issues (i.e. medications, nutrition, psychological); these will need to be considered when making the best treatment plan.

The first step in the program is to ask your child's doctor to advise you on what are the safest and most effective ways to resolve your child's constipation. Once the physician has made recommendations, you should try to follow these as closely as possible. If you fear these recommendations will not work for your child, then voice these concerns to your physician. Most likely, your child will be requested to eat more fiber-rich foods and drink more fluids (water). If your child consumes considerable quantities of constipating foods or drinks, then these will need to be limited (be

careful when limiting calcium-rich dairy products, since these are important for bone development). If your child is taking constipating medications, they may need to be changed or discontinued.

A laxative or medication to stimulate bowel movements will probably be the main course of treatment. There are many laxatives to choose from (see list below). They all act very similarly, with only slightly different side effects. Some laxatives have ingredients that should not be consumed by individuals with special medical conditions, and if there is any question, a doctor should be consulted. Enemas or suppositories may be recommended to initially clean out the lower bowel and rectum. These should not be used long-term, except in difficult or special circumstances. Enemas and suppositories are usually safe, but they are more invasive, instill more fear and are embarrassing for the older children.

> **It is generally accepted by most physicians, that taking laxatives and medications by mouth are preferable long-term to anything given by rectum (enemas and suppositories).**

Children with severe constipation, especially those with the inability to have a bowel movement (impaction), may require a very aggressive initial approach. As stated earlier, many of these children develop severe abdominal (belly) pain, and they will need to be evaluated to make sure there is no underlying medical cause for the pain. These children may require hospitalization to clean out the impaction. Taking strong laxatives by mouth or through a tube inserted into the stomach is often needed to clean out the bowel. Enemas may also be required to get the lower colon or rectum cleared before the other medications or laxatives will work. In some cases, a disimpaction is required to remove very hard and large stools that are lodged in the rectum. A disimpaction usually requires a doctor or nurse to insert their finger into the rectum to "dig out"

the stool. Rarely, a child will need to undergo general anesthesia (put to sleep) to have this done. After the bowel is completely cleared, treatment is similar to other children with milder cases of constipation, except the treatment is more closely monitored and continued for a longer period of time.

DIET

Fiber is the mainstay for ensuring healthy and regular bowel movements. Today's children typically do not get enough fiber to help prevent constipation. It is very important to establish a diet for your child and family that prevents constipation and the problems it can cause. Most experts believe children with constipation should increase their fiber intake to equal in grams at least the child's age (years) + 5. For example, a six year old child should have 6+5=11 grams. Foods typically rich in fiber include: fiber rich breads, crackers, cereals, fruits (raisins, dates, prunes, pears, and cantaloupe) and vegetables (broccoli, beans, corn, peas, popcorn). For a complete list of fiber content in foods refer to ADDENDUM A at the end of this book.

It is not always easy to get a child to consume the amount of fiber that is required. This is especially true if a child's diet has been limited to certain foods or if the child is "picky". Recipes that increase fiber intake are available, but these are not usually child friendly. Refer to ADDENDUM B at the end of this book to find child friendly recipes that help with constipation. It may also be necessary to disguise the fiber or make the entire family modify their diet. Adding fiber supplements such as unprocessed wheat bran to favorite foods is also an excellent idea.

Although fiber is important, it is just one part of a properly balanced diet. It is possible that too much fiber may reduce the amount of calcium, iron, zinc, copper and magnesium that is absorbed from foods. Deficiencies of these nutrients could result if the amount of fiber in the diet is excessive, especially in young children. Fiber supplements that are sold as laxatives should be used

under a doctor's supervision. The safest way to receive maximum benefit is to eat a variety of fiber-rich foods.

Many foods are very effective in regulating bowel habits. In addition to fiber, foods high in natural sugars like sweet potatoes, peaches, and pears also stimulate bowel movements. Raw vegetables have more roughage and also increase the frequency of stools. However, it is often difficult to get a child to eat or drink enough of these foods to gain a significant benefit. The key is to provide healthy choices of food and drinks that are high in fiber, natural sugars, and roughage. You should also increase fluid intake and decrease constipating foods. Drinks will keep plenty of fluid in the intestines and allow the stools to be softer, even when some of the fluid is absorbed in the colon. Constipating foods primarily consist of dairy products, such as milk and cheeses. A parent must be careful when limiting dairy products because children need calcium to grow and have healthy bones. Your child's doctor may recommend foods, vitamins, and drinks with calcium supplements to replace some of the dairy products.

Diet Recommendations:
- **Fiber**
- **Natural Sugars**
- **Roughage**
- **Fluids (namely water)**
- **Avoid constipating foods**

Diet tips for infants up to 1 year of age:
Constipation is more common when changing from formula or breastmilk to cow's milk. Your child's doctor may suggest adding syrup to each bottle (ex. 1-3 tsp/bottle). For infants older than four months (less than four months consult your physician), add fruit juice to formulas, milk and baby foods. Rule of thumb = 1 ounce/months in age, twice a day. Pear, apple and prune juices are

excellent fluids since they are rich in fiber. Also, fruits and vegetables should be consumed in larger quantities if your child is constipated. Excellent fiber quantities are found in peas, beans, apricots, prunes, peaches, pears, plums, and spinach.

Diet tips for children over 1 year of age:
Increase fruit juice such as apple, pear, grape, and prune (citrus juices are not high in fiber). To meals, add fruits and vegetables with high fiber content: broccoli, bananas, peaches, pears, prunes and dates. Increase whole grain foods such as bran muffins, graham crackers, oatmeal, brown rice and whole wheat bread. Popcorn is a nutritious, high fiber snack for children over four years old (popcorn is a choking hazard). Decrease foods that are constipating such as ice cream, cheese, milk, and other dairy products.

EXERCISE
Increased physical activity improves constipation. Children with constipation can become inactive or distracted from exercising. Burning calories improves digestion and increases the bowels ability to move stool through the intestines. With increased activity, children develop muscle tone throughout their body that is important for normal bowel functions.

AVOID CONSTIPATING MEDICATIONS
Several medications may inhibit normal bowel functions and cause your child to develop constipation. Vitamins with iron are constipating. Medications that prevent bladder spasms or bowel cramps are commonly constipating. Several of the psychotropic medications that are used to treat depression, psychological disorders, ADHD, and other mental problems can contribute to the development of constipation. You should consult your child's doctor to determine if any of her medications are constipating and if they can be avoided or substituted.

IMPROVE POTTY HABITS

Many books on potty training describe how constipation can cause large and hard stools that push against the bladder and cause spasms or prevent the bladder from emptying. This theory has never been proven, and although this explanation is plausible, in my opinion, it is unlikely to be the case. Certainly, if the stools are huge, then a mass-effect can occur and cause external compression or irritation to the bladder. I believe that a child's unwillingness to use the restroom often is the most obvious explanation for the development of constipation and other bladder problems. Think about it, if a child does not want to use the restroom to poop, then she will develop constipation. Although it may not be as obvious, often that same child probably does not want to use the restroom to urinate. Holding both urine and stool is the result, which then causes bladder spasms or the inability to relax and empty when she does go. Furthermore, as the constipation worsens, it becomes more difficult or even painful to have a bowel movement, which further discourages her from wanting to go to the potty often even to urinate.

The best times to have a child sit and attempt to have a bowel movement are shortly after a meal. A normal body reflex, called the gastrocolic reflex, stimulates the desire to poop during and shortly after a meal. When the stomach is filling with food it sends a message to the colon (large intestine) to empty. You are more likely to have a child want to have a bowel movement after a meal than any other time throughout the day. It is recommended that you send your child to sit on the potty after each meal to encourage him to have a bowel movement. This will increase your child's chances for bowel movement success!

Since most children develop constipation from holding, and since treatment for constipation involves getting children to use the restroom more frequently, it is extremely important to make sure your child has excellent potty habits for both urine and stool. In other words, since children tend to hold both urine and stool, it is

69

important that your child goes often to urinate and have bowel movements. If your child goes to urinate often, he will most likely have more frequent stools. Make the bathroom a priority, not an option. Be sure you keep a close eye on the urinating habits as well as the bowel movements. Have your child go often (at least every 2 hours) to pee and poop. Have him sit to urinate. The more times your child sits to pee, the more chances he will also have a bowel movement. It is a numbers game—if you increase the opportunities to have a bowel movement, the more likely it will happen. If you focus on pee or poop without focusing on the other, you are more likely to fail in your attempt to correct either problem.

ENEMAS/LAXATIVES/SUPPOSITORIES

Medicines are usually necessary to treat childhood constipation. Changing a child's diet is helpful, but it does not usually correct difficult constipation problems. Improving a child's potty habits is also crucial, but it is usually more helpful in preventing constipation than it is in correcting a significant constipation problem. Medicines, laxatives, enemas and suppositories are commonly needed to re-establish regular bowel movements and eliminate the pain. They are also very helpful in shrinking a stretched colon back to normal size and preventing further constipation episodes. Once the constipation is no longer a problem, diet and potty habits can prevent further problems. Medications, laxatives and enemas will be discussed in detail later in the book.

BIOFEEDBACK

Biofeedback is sometimes used to teach children about the use and activity of their pelvic muscles (sphincters). It usually involves placing patches near the anus (sometimes an anal probe is inserted) and connecting them to a computer/monitor. The purpose of biofeedback is to show children when they are relaxing and tightening their sphincter muscles. By teaching a child about normal bladder and bowel functions, as well as instructing them how and when to relax their sphincters, we can teach a child how to use the

restroom normally. Although biofeedback is effective in some children but not in others, it is certainly worthwhile in children who fail standard treatment or have severe constipation or multiple potty habit problems.

TIPS FOR CHILDREN OF DIFFERENT AGES
INFANTS
There are several actions that can be taken to help your baby avoid constipation. Here are a few suggestions:

- Massage your baby's tummy.
- Move your baby's legs in a cycling motion
- Give your baby a warm bath
- Double check to ensure you are mixing the formula correctly
- Give your baby cooled, boiled water (extra fluids are helpful)
- Add syrups to your babies bottles (ask your physician)

Once your baby is between 4-6 months old, you can start introducing more cereal, fruit and vegetables into their diet. Juices that contain prunes, pears, apples and berries are great additions to their diet. If your child is willing and able to eat them, foods high in fiber will help to prevent constipation. For specific recommendations on how to prevent constipation consult your child's doctor.

TODDLERS AND SCHOOL AGED CHILDREN
Since the majority of children with constipation do not have a medical disease or condition, the following are good ideas to help them with their constipation problem.

- Make sure your child uses the potty at school, at daycare and when with babysitters. Be sure your child is not concerned about a lack of privacy or cleanliness of the bathroom at these places.

71

- Discuss any prior experiences that make your child want to avoid going to the bathroom. If your child had a painful or scary experience using the potty, make sure you discuss and avoid these circumstances in the future.
- Provide your child with a well-balanced diet. Fiber-rich foods are very helpful.
- Attempt to prevent your child from catching any illnesses. In young children, constipation frequently develops after an illness and it can worsen if your child develops a severe diaper rash or dehydration.
- Make sure your child has a good potty training experience. Potty training can confuse your toddler into becoming constipated.
- Discuss your problems and concerns with your child's school. In older children, constipation often develops when the child enters school. There are several reasons why your child may refuse to use the restroom while at school.

TEENAGERS

Lines of communication need to be open between you and your teenager. If your child has a problem with constipation, try to make every effort to make him feel comfortable discussing the problem with you. Teenagers are oftentimes very embarrassed about potty problems and are reluctant to discuss the problem with others. Constipation in teenagers is usually not a newly developed problem. Most teenagers with constipation have had the problem since childhood. If your teenager has had previous constipation, be prepared to completely restructure his potty habits, so he will not have long-term problems.

Constipation can become a problem in teenagers who refuse to go to the restroom while at school. Today's high schools are quite large, and only a short period of time is allowed between classes. This may discourage your teenager from attempting to have a bowel movement while at school. If your teenager is too embarrassed to use the restroom at school, or does not have enough time to go,

then discuss these issues with him and work with the school to resolve the problems. Teenagers need to be encouraged to develop a new routine. Encourage them to make healthy food choices, drink plenty of fluids and exercise regularly. These things are important for long-term health as well as good potty habits.

ENCOPRESIS (STOOL ACCIDENTS)

Encopresis remains a common and significant problem in children. It is estimated that one to three percent of the general pediatric population is afflicted with this problem. Encopresis is becoming so common that many of the larger pediatric institutions have started encopresis clinics.

In most kids, the accidents occur simply because they waited too long and the stool needed to come out. Some children would simply rather have accidents than use the restroom. This is especially true if the child is young and allowed to regress to diapers or pull-ups. Soiling, another term for encopresis, is most often associated with constipation that has occurred over time. If the constipation continues it can lead to a buildup of stool in the rectum called an impaction. When an impaction is present, the looser stool upstream may seep around the impaction and leak without the child being aware. With chronic (long-term) constipation, the muscles and nerves that help with normal bowel movements may be damaged such that many children cannot feel the need to go. As a result, the intestine may be so full the stool has no where to go but out the bottom, which many times results in soiling. These children are not able to feel the sensation of needing to have a bowel movement, and therefore, are unable stop the stool from leaking.

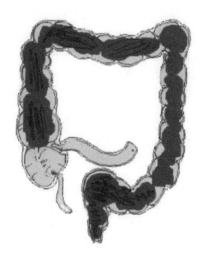

Once a child develops a significant constipation and soiling problem, it is difficult to correct without aggressive treatment. Treatment for encopresis is typically similar to the treatment of constipation, but it is more intensive and consists of a broad approach that involves disimpaction (inserting a finger to remove large/hard stool), laxatives/enemas, training and education. The treatment program usually involves the following sequence:

1. Medical evaluation by your child's doctor or a specialist
2. Education of the child and parents about constipation
3. 'Clean out' if an impaction is present
4. Maintenance treatment
 - Stool and voiding diary
 - Dietary changes-increase fiber
 - Medications/laxatives
 - Potty habit improvement
 - Fluid intake increase
 - Exercise
 - Rewards and praise
 - Counseling
 - Monitoring for recurrent constipation

REFUSING TO POOP IN THE POTTY

Children tend to control their bowel movements prior to controlling their urine; at least that is what we think. It is very hard to determine if a young toddler intentionally wets or has a bowel movement. Since children tend to obviously hide or grunt to have a bowel movement, we are more aware of when they are in control of this process. It is believed that children develop control of their bowel movements at a young age. However, just because a child does not hide or posture when urinating does not mean they do not exercise control of their bladder. Since urination is relatively effortless, toddlers may urinate often without exhibiting obvious signs of control.

Since having a bowel movement requires a slightly different process, some children may show earlier signs of wanting to go poop in the potty. Having a bowel movement usually requires some straining and children who are toilet training tend to strain when trying to first use the potty. Some children may even be "potty trained" for their bowel movements well before they will urinate in the potty. Just the opposite may also occur. Some children will pee in the potty, but insist on having a diaper on before having a bowel movement. A classic example of this is when a child will urinate in the potty and then ask for a diaper so she can hide in the corner to have a bowel movement. It can be extremely frustrating when a child refuses to use the potty to have a bowel movement. Parents are commonly confused at what action they should take since the child clearly knows what she is doing and has complete control of her bowel movements. To add to the frustration, most of these children will ask to have their diaper changed or removed after they have pooped.

Training your child to use the toilet for bowel movements is not much different than training him to urinate in the toilet. First, your child must show signs of being "ready" to train. The signs your child will display for having control and interest in being trained for

75

having a bowel movement are no different than the signs that he is ready to be potty trained for urine. If you proceed with general potty training (whichever technique **you** choose) and your child is only willing to pee in the potty, then talk to him and see if you can understand his reasoning. Sometimes the simplest concerns or misconceptions can be relieved, and your child will start to poop in the potty. However, it is not usually this easy. If your child is not able or refuses to discuss his issues, you may be forced to decide whether you will permit him to use the diaper or pull-up for having a bowel movement. If you are patient, he will eventually have a bowel movement in the toilet and become completely potty trained.

If you want to take a more active role, then you may need to spend more time explaining and exhibiting the bowel movement process. Consider having him observe you having a bowel movement. Explain everything you are doing in very simple terms. Tell him he will need to sit on the potty with his legs separated and lean forward. This flexion at the hips improves sphincter relaxation. He can even see the poop go in the potty if he likes. Tell him that water may splash, but it is normal and not scary. Have your child watch you wipe and ask him to flush your BM "bye-bye". If your child has a bowel movement in his diaper, do not scold him but instead, tell him next time he will sit on the potty to poop. Have him help with shaking the poop out of the diaper and into the toilet. Ask him to flush and sit on the potty to wipe his bottom again. If he continues to refuse to poop into the potty, have him sit on the potty with his diaper on and allow him to proceed with having a bowel movement. Some advocate cutting out the bottom of the diaper so he will still poop in the potty.

Timing is also important. The body has a normal gastrocolic reflex which triggers a BM during and after meals. If you have your child sit on the toilet 10-15 minutes after each meal you are more likely to have success at having a poop in the potty. If your child complains of a stomach ache while eating, tell her to go potty immediately.

Getting a child to poop during these times is even more likely if the poops are soft, frequent, and easily passed.

It is very common for children who refuse to poop in the potty to develop constipation. Even if constipation is not a problem, a simple and safe tip to get your child to use the potty for bowel movements is to cause your child to have more frequent and soft stools. Not only are large and hard stools more frightening for a child, but frequent and soft stools are harder to hold while urinating on the potty. Your goal is to make sure the stools are very soft (the consistency of rotten bananas) and occur often (at least twice a day) so your child is less successful at holding. Diet changes, stools softeners, and laxatives can be used to promote more frequent stools. If a laxative is used, it may need to be continued for several days or weeks until your child uses the potty on a regular basis. I have used this technique on many occasions with excellent results. Your child's doctor may have special concerns or preferences in regards to your child taking a laxative for this purpose.

Do not forget that urinating and having a bowel movement are closely related. Do not fall into the trap of only focusing on one problem. Simply having your child sit (including the boys) to pee will increase your chances he will become more comfortable on the potty. The more he sits to pee the more chances you have he will have a BM in the potty. If you implement a bowel program that causes frequent and soft poops, then bowel training is even more likely to happen. Remember, if you have successfully trained your child to use the potty for either pee or poop, use this skill to your complete advantage and have them go potty often. This will encourage the other, whether pee or poop, to occur. You may need to be structured, firm, and consistent with your requests to use the potty.

If your child is able to convince you on several occasions to allow her to use the diaper or pull-up for having a bowel movement, then she will delay the process of going in the toilet. Remember "tough

love" may need to be tried, especially if all else has failed. One example of tough love is to try "poop jail". This is somewhat controversial, but recommended by a reputable potty training "expert". It is most effective when you know your child needs to have a bowel movement. Poop jail involves having your child stay in a room without any toys or distractions (much like a timeout), and instruct her that she can come out when she goes poop in the potty. Advocates state this may be preferred to forcing your child to sit on the potty and poop on command. Simply placing your child on the potty can work, and it is probable that eventually she will go. Once she realizes she can go poop on the potty and not be alarmed, then she will be more willing to do it again. If you show significant praise towards your child and reward her for having a bowel movement on the potty, this will also encourage her to use the toilet for both urine and stool.

Before trying these tactics, consult your pediatrician or family physician to see if she agrees with this approach.

CHAPTER 11

MEDICAL TESTS THAT ARE SOMETIMES NECESSSARY

Once a physical exam does not reveal any significant findings to explain the symptoms and difficulties a child is having, then further testing may be pursued. As explained earlier, many of these tests may not be necessary, but it is up to your physician to determine if further evaluations are needed to confirm there is no underlying medical issue.

CHILDREN WITH URINE PROBLEMS

URINALYSIS

The urine should be checked in any child with significant urinating problems. This commonly involves testing the urine with a dipstick or microscope to look for blood, diabetes, and infection. Blood in the urine (hematuria) may indicate infection, inflammation, stones, rare tumors, and urinating problems. If the blood in the urine is invisible (microscopic hematuria), the child does not have any pain, and the exam and urine stream are normal, it is unlikely there is anything significantly abnormal. The cause of the invisible blood in the urine in children is not usually found, since significant problems do not usually exist. Children with problems related to poor potty habits can stretch their bladder, pee with significant force, and cause irritations of the bladder lining that cause blood in the urine that is not visible to the naked eye. It is the responsibility of the pediatrician or family physician to limit testing in children with microscopic hematuria, without missing any of the uncommon medical problems. An ultrasound is not necessary, but may be performed to make sure nothing is obviously wrong with the kidneys and bladder. Your doctor may obtain other urine and

79

blood tests to make sure nothing is wrong or ask that your child see a kidney specialist (pediatric urologist or nephrologist).

Urine tests that show the presence of sugar and ketones may indicate the child has diabetes. Diabetes can cause a person to urinate often (frequency) and drink more. Prompt medical treatment of diabetes will correct urinary frequency and excessive thirst. If the urine test shows a urinary tract infection (UTI), it will need to be treated with antibiotics. Evaluation with an ultrasound should be performed in most cases. Boys, infants, and children with abnormal ultrasounds and infections with fever need to have a bladder x-ray to make sure nothing is wrong with the bladder, urethra, and kidney tubes (ureters). The bladder x-ray, called a voiding cystourethrogram (VCUG), requires a tube (catheter) to be inserted into the bladder. The VCUG can be performed with regular x-ray dye or by using nuclear material. The VCUG is sometimes painful and traumatic and should not be obtained in every child with a urinary tract infection (my opinion). My extensive experience with children's UTIs has shown that most infections occur in girls with abnormal potty habits that have normal ultrasounds and infections without fever. By simply treating the abnormal potty habits, many children will be spared further infections and medical testing.

ULTRASOUND
Ultrasound is a technology that allows pictures to be taken of internal body parts. Ultrasound pictures of the kidneys and bladder are ideally suited for children with all kinds of urinary problems. Ultrasounds are very child friendly, since they do not hurt, and the child can usually see what is taking place. In children with blood in the urine or urinary infections, ultrasound provides reassurance to both physicians and parents that nothing unusual or serious is wrong with the kidneys and bladder. Ultrasound can show tumors, cysts, blockage, stones, and other abnormalities. Relatively speaking, ultrasound is cheaper than most types of x-rays. I commonly use ultrasound in my practice because it is child friendly,

easy to obtain, and does not give any radiation. In children with bad potty habits, ultrasounding the bladder after urination will show me and the parents how well the child emptied his bladder. The amount of urine left behind in the bladder is called the post-void residual (PVR). A large PVR indicates the child did not relax and do a good job at emptying his bladder. Many, many times parents are very surprised to see how much urine is left in their child's bladder, when the parent has assumed their child has emptied. Showing the PVR to them increases the parent's willingness to believe that the child's potty habits need to improve.

VOIDING CYSTOURETHROGRAM (VCUG)

An x-ray is sometimes needed to make sure nothing is wrong with the bladder or urethra. The VCUG is very unpopular with the children and parents. A plastic tube (catheter) is inserted into the urethra, so that the bladder can be filled with x-ray dye or radioactive tracer. The catheter insertion can be painful and difficult, especially if the child is moving and resistant. Children must remain still, possibly requiring them to be restrained, while the bladder fills with the dye. X-ray pictures are then taken to determine the size, shape, and contour of the bladder while it fills and empties. A normal bladder will hold the correct amount of fluid, have a smooth/round appearance, and empty completely without refluxing or filling any other structures. Most children are asked to urinate while lying flat on the x-ray table. A VCUG should be performed only in children with a history of urinary tract infections or significantly abnormal urinary problems.

ABDOMINAL X-RAY

Plain x-rays of the stomach, intestines, and other structures of the abdomen can be obtained with one single film. There are no special requirements, but the child does need to remain still. This x-ray is called a "KUB". KUB stands for kidney and urinary bladder. This x-ray does not provide much detail, but it will sometimes provide information about possible causes of belly pain. For example, constipation can be diagnosed if significant stool is in

81

the colon. A KUB may also show kidney stones or other subtle findings.

URODYNAMICS

Urologists will request bladder function tests when there is some concern about the bladder size, pressure, and ability to empty. Urodynamics are bladder tests that are usually performed in a urologist's office. A tube (catheter) is inserted in the bladder, much like obtaining a bladder x-ray. The tube can show how well a child empties, and it allows fluid to be filled into the bladder, which indicates how much fluid the bladder will hold. Bladder pressures and spasms can be recorded. X-ray dye can fill the bladder if x-ray pictures are also needed. If there is leakage, this will be shown and recorded. The child is told to pee when they are full. Urine flow can be measured to see if it is normal. Patches or electrodes can determine if the urinary sphincter or pelvic muscles are doing what they are supposed to do when the bladder is filling and emptying. Since a catheter is required, children do not like this test. If they cry or move a lot, the results may not be accurate. However, urodynamics can be helpful, especially if traditional treatment fails, or if the parent or child do not understand what is happening with urination.

BIOFEEDBACK

Biofeedback is becoming more commonly used in children to show them how their pelvic muscles and sphincters work. This test usually involves placing small patches on the bottom (near, but not on the anus) and hooking them to a machine. If the child relaxes the muscles, the machine shows this on a screen in a way the child can understand. Likewise, if the child tightens the muscles, then she can also see this on the screen. The purpose is to show a child how to relax the pelvic muscles and sphincters when she pees in hopes she will learn to empty her bladder better. If the child urinates while hooked up to the machine, she can be shown that the muscles should be relaxed. Doing this several times gives the parents and child "feedback" about what is taking place and what

needs to be done to correct the problem. If done correctly and under the right circumstances, children do not mind this test since it does not hurt and it can be turned into something interesting and informative.

CT SCAN AND MRI

These are very expensive and involved x-rays. The children are sometimes asked to drink a liquid that will show detail regarding the intestines. Intravenous dye is usually administered to light up abdominal organs, namely the kidneys, ureters, bladder, liver, and spleen. A needle injection is required to give the dye, and sometimes children need to be sedated in order to be still during the x-ray. Assuming a child's physical exam is normal, and his complaints are classic for having bad potty habits, both CT scans and MRIs are usually not needed. If a child has unexplained abdominal pain or if there is concern regarding the nervous system, then these x-rays may be necessary.

CYSTOSCOPY AND URETHRAL DILATIONS

In the past, urologists routinely recommended a scope procedure of the urethra and bladder to make sure nothing was physically wrong in children with various urinary symptoms. The scope procedure requires children to be put asleep with general anesthesia. While asleep under general anesthesia, the urethra can be dilated with a large metal rod or even cut with a small blade. In most cases, nothing is found during the procedure that provides an exact diagnosis related to the child's symptoms. In the past, urologists thought that the children were having difficulty urinating because their urethras were too small. In most cases, the urethral dilation caused children to have pain when they urinated or tried to hold their urine. In a few cases, children did void better after the dilation, but typically, there was no improvement. Most pediatric urologists do not recommend this today, and it is considered to be "old medicine." We now know the reason most children have difficulty going potty is not because their urethra is too small, but because they have poor potty habits. I do not believe cystoscopy and

urethral dilations should be done except in those very few cases when all other treatments have failed, and the child's problems cannot be easily explained.

CHILDREN WITH BOWEL PROBLEMS

PHYSICAL EXAMINATION

Your child's physician will most likely feel and lightly push on the abdomen to feel for areas of distension or firmness in the colon. A rectal exam is also commonly performed. This involves inserting a finger into the rectum to feel for masses, impactions, or test for blood or other problems. The anus is also inspected for tears, fissures, or other abnormalities.

ABDOMINAL X-RAY

This is a plain x-ray (KUB) in black and white that can reveal abnormal gas and stool patterns in the intestines. It can also provide information about other causes of abdominal (belly) pain and problems.

ABDOMINAL AND PELVIC ULTRASOUND

Ultrasound involves sending sound waves into the body and taking pictures. The sound waves are reflected off the internal organs and provide information about the internal anatomy. Ultrasounds can show if the child has stool retention or if other abnormalities exist. Ultrasound can show if a child empties his bladder, which may be important when trying to understand the underlying reason he is constipated.

BARIUM ENEMA X-RAY

This is an X-ray (see below) examination of the large intestines. Barium sulfate is administered into the rectum via a small tube, and an X-ray is taken. Barium sulfate is a "dye", which makes the colon visible on X-ray. This test is usually obtained when looking for medical causes of constipation (ex. Hirschsprung's Disease). If the

lower colon is narrow, then Hirschsprung's Disease might be the problem. If other abnormal findings are seen in the colon, then more tests may be needed to make a diagnosis.

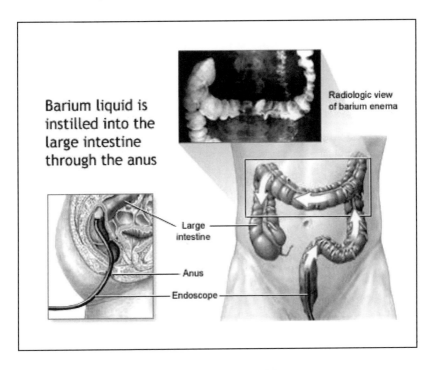

Barium liquid is instilled into the large intestine through the anus

Radiologic view of barium enema

Large intestine

Anus

Endoscope

COLONOSCOPY

A doctor performs a procedure where a long flexible tube with a light and scope is inserted into the rectum and the entire large intestine (colon) is visualized. This procedure requires sedation or general anesthesia while the child lies on her side. Colonoscopy is usually reserved for those who have failed conservative treatment, since it is uncommon to find abnormalities in most children with constipation. Most physicians believe that colonoscopies should be reserved for children with significant blood in the stool, family history of polyps, and constipation that fails conservative treatment. If an abnormality is found, a small piece of tissue (biopsy) can be removed for examination.

Colonoscopies should probably not be initially performed in children with constipation that is associated with other potty habit problems. If one does not address all of the potty habit issues, including urinating problems, prior to recommending a scope, then an unnecessary procedure may be performed. Your child's doctor should know the appropriate indications for performing a scope procedure. A gastroenterologist is best suited to recommend or perform this procedure.

BIOPSY

A tiny piece of the intestine is removed and examined for missing nerve cells (Hirschsprung's Disease), polyps, or other abnormalities of the colon. The biopsy is usually done through a scope inserted into the rectum/colon, but it can also be obtained during a surgical procedure.

RECTAL MANOMETRY

In this test, a balloon is inserted into the rectum and inflated with air or fluid. Children can normally tolerate around 20 cc (2/3 ounce) of fluid before they feel the urge to defecate. Children who have severe or long-term constipation can tolerate up to five times that amount before having the urge to defecate. This usually implies the rectum has been stretched, and the child no longer has the normal urge to go.

CHAPTER 12

GENERAL TREATMENT PROGRAM FOR ALL CHILDREN WITH URINE AND BOWEL PROBLEMS

GENERAL GUIDELINES

There are many treatments and recommendations for correcting abnormal urine and bowel habits in children. There are, however, no magic medications or cures that will take care of these problems. Parents and caregivers wish for an easy cure-all for these problems, but unfortunately, there usually is none. Most pediatric urologists advise parents that abnormal potty habits in children are very common, and in order to achieve success, the parents will need to restructure their child's bathroom habits. The advice is easy to give, but hard to follow. My advice to parents is not dissimilar, but I emphasize a total commitment to a "program" that is required to overcome the difficult influences that cause a child to have potty habit problems.

My program requires a very committed and loving approach that is consistent, simple, direct, and effective.

Parents need to be convinced that the program will work once everyone is assured there is no underlying medical cause for the problem. In most instances, the children are too young to understand the basic fundamentals of the program, and they certainly do not desire to make the commitment that is often required for success. Parents will need to be compliant, even if they do not completely understand why their child is having problems. In many cases the parents will need to consider implementing the practice of "tough love" when approaching their child's potty problems. Parents are not always willing to be strict with the

treatment plan, and they often need to be reassured the plan will work. If the treatment plan is reinforced to the parents, the child can gain a better understanding of the program's importance and be willing to continue with it.

Parents are often concerned there is a medical problem that is interfering with their child's ability to have normal bodily functions. A visit to a physician or care provider may be required in order to determine if a child has any medical problems. It is not always easy to convince parents that no medical explanation exists for why their child has abnormal potty habits. If a child has had normal checkups and physical examinations, it is unlikely there is a medical explanation for the urine and bowel difficulties. Also, parents should ask themselves whether or not their child had normal potty training as a toddler and if the child has had some period in his life when bladder and bowel functions were normal. If the child was easily potty trained or had days in his live with normal bladder and bowel functions, it is unlikely there is anything medically wrong.

Some parents still believe that a medical condition is causing their child to have difficulties, and these parents may seek a second opinion or request further evaluation. I realize it is not always easy to trust medical advice that says your child is normal when she is having significant problems urinating or having a bowel movement. Ideally, parents should be easily convinced that their child is "normal" without performing unnecessary consultations and testing. If your child fails to improve with the treatment plan, then consultation with your child's primary care physician or a pediatric specialist is advised. Once it is established that no medical problems exist, parents can whole-heartedly pursue the treatment of correcting their child's potty habits.

Children between two and six years barely understand the basic functions of urine/bowel activity. They do not usually benefit from much explanation about what they are doing wrong, and how it is going to be corrected. Parents should simply state that, "Because

88

you are having problems going to the bathroom, we are going to make some changes that will help you use the potty better." Attempting to ask a young child for approval or information about his potty habits is probably not going to be worthwhile. When parents attempt to ask children about their potty habits, the responses are not usually reliable and are often confusing. When there are minimal and isolated issues related to using the potty, then interactions and discussions with the child might be of benefit. If the problem escalates, a parent usually has to resort to completely restructuring the potty habits. This does not mean that young children not provide some valuable feedback and input, but it remains the responsibility of the parent to take the corrective action. This approach may seem strict, but younger children with abnormal potty habits usually require a firm and consistent realignment of their potty habits in order to improve them. Remember "tough love" may be required.

Older children, usually above age six, can understand some of their actions that predispose them to having potty problems. These older children will need to be better informed of what they are doing wrong and why they need to make changes. Even so, they are not usually able to comprehend the potential benefits of the treatment program, and they may resist many of the changes that are required. This age still requires that the parents take charge of the complete program and make sure that the children are following all of the steps. If the parent does not completely inform the child of what is required, then the child is more likely not to follow directions. A rebellious adolescent will even more so require the parents to make sure their child understands that problems with bathroom habits must be corrected. The parent should remain in charge. The same is true for older teenagers, but some salesmanship on the part of the parents may be necessary in order to get the child to buy into the program.

It is important to once again discuss some of the psychosocial issues that are involved with the restroom itself. The restroom can

be a fascination to some of the younger children, and sometimes they like to visit strange restrooms and explore. Other children may be fearful of the restroom and the commode, especially the unfamiliar ones. To some, the toilet makes loud and unfriendly noises, and they fear falling into the toilet. Older children may not feel comfortable in a strange bathroom or simply view it as a place that is not fun.

Restrooms at school and public places are many times thought to be very dirty, and parents sometimes discourage their children to use them. Fears of bacteria and sexually transmitted diseases are sometimes factors that discourage the use of public restrooms. Older children, especially those in middle school and high school, are not allowed to use the restroom frequently, or they are afraid to do so for fear of being late to classes. Many children don't want to go to the school restrooms because graffiti, obscenities, and unfriendly children may be present. It is not uncommon for children to state that the stall doors are missing or do not lock. Toilet paper is not always readily available. In some schools, the children are asked to go to the school office to get toilet paper to carry to the restroom. Restrooms at public places are frequently crowded and are commonly lacking many of the previously mentioned "potty luxuries." If a clean and easily accessible restroom is not readily available, then children may wait until they get home to use the bathroom. Parents need to be aware of the potential issues that may interfere with their child's willingness to use the restroom. These will need to be addressed so that a successful outcome can be achieved.

THE PROGRAM

I call the treatment plan a "program" because it involves more than just focusing on one problem with one solution. Remember that many parents and physicians fail in their attempts to correct abnormal bathroom habits in children, because they try to focus on one symptom and treat it with too narrow advice or a "magic pill". This approach works with many other medical problems, but not

with children's potty habits. The program involves restructuring your child's potty habits with strict guidance and directions. It requires that all aspects of using the bathroom be addressed so that your hard work will not be sabotaged by outside factors. Additional help from devices and medications may be needed in some cases. Consultation from an expert, preferably a pediatric urologist, should be obtained if positive results are not obtained. If you have gone as far as to read this book then you probably need to follow the "program" very closely. ***The good news is this program works!*** You just have to be committed and willing to give all of it a try.

| #1 | Build up your "team". Reinforcements are mandatory if successful results are going to be achieved and maintained. |

Grandparents, baby sitters, teachers, and everyone that has significant contact with your child will need to help reinforce your rules and instructions. If not, the child will become confused or manipulate the situation to their liking. It can be difficult to consistently implement the lifestyle changes that are needed to correct poor potty habit behavior. Parents will need help from everyone who is in routine contact with their child to see that the child remains on track with the program. Teachers and daycare workers, who are responsible for several children, will need to be informed of the rules so that they can help implement and not interfere with the program. Everyone in close contact with these children will need to encourage frequent and non-hurried visits to the restroom.

A successful program to correct abnormal potty habits is very achievable, but it requires significant work and dedication by everyone in contact with the child. I tell parents to inform everyone around them that their child needs to be instructed to use the restroom often and to take her time. Of course, teenagers and older children may not want others to know about their problem, and this may require some strategic instructions be provided to the teachers and family members so that compliance is achieved without the child being embarrassed.

91

Counseling may be beneficial if the parents suspect significant events have occurred or if they sense there has been a considerable change in the child's behavior. If one can identify significant issues through counseling, including recent deaths, divorce, school issues, abuse, and new siblings, then chances for recovery will be improved, and the parents can better focus their attention on correcting the abnormal potty habits. Routine potty problems do not, in and of themselves, require counseling, and parents should be prepared for addressing these problems themselves.

| #2 | Request your child to use the restroom every 1½ - 2 hours during the day, everyday. Children must use the bathroom the moment they wake up and at least every two hours during the day until they go to bed. This advice is confusing for parents with children who already go often. Children that go often also have episodes when they do not go frequently. These children will hold it and will need to be told to use the potty. Avoid using statements like "wait till we get home" or "try to hold it longer." Do not ask your child if they need to go potty or if they can go. Just simply say, "It is time to go potty." Make sure this rule is also followed when the child is away from home and at school. With time, he will understand that this request is non-negotiable. Give him a hug and tell him you love him, but tell him it is time to go potty.

| #3 | Children should practice "potty yoga". Your child should be told to relax and take his time in the restroom. Pit stops are not allowed. She should sit on the potty for at least 3 minutes (most children think it is 3 hours, but it is just 3 minutes). If she comes out too soon, send her back. Just because she thinks she is finished, she should still stay on the potty a little longer. Children should not fidget, push (strain), or be in a hurry. Normal urination does not work with straining, and this should be avoided. In other words, do not tell her to "push and get all of the pee pee out." If she is straining or trying too hard, tell her to stop and relax.

Close the bathroom door (quiet time) and tell him to sit deep into the potty with his legs apart. All children with potty problems should sit on the toilet and relax (including the boys). The more he sits on the potty, the more relaxed he will be and the more often he will empty and have a bowel movement. Closing his eyes and taking deep breaths (potty yoga) may be helpful. It is acceptable for him sit backward and lean against the back of the toilet if he prefers. Do not send him with a book, game, or toy. This will only distract him from understanding the subtle sensations of normal emptying of his bladder and bowel.

#4 Children with abnormal potty habits should avoid stimulants that prevent them from being able to relax on the potty. This becomes especially important when a child has ADD, ADHD, or a classic anal-retentive personality (Type A personality). They should also avoid drinks and foods that are potentially irritating to the bladder. There are many items one could list, but the biggest offenders are caffeine drinks, chocolates, and sugar/carbonated drinks. It is common for parents to encourage their child to drink more water. The problem is not making enough urine; it is letting the urine out often. Therefore, drinking more water is optional.

#5 A bowel program is essential. Since the focus of our treatment is to encourage frequent bathroom visits (for both urine and stool), we do not want to be sabotaged by any bowel problems. Children with constipation obviously need a bowel program since painful, difficult, and large bowel movements will discourage a child from using the potty. It is not difficult to convince a parent whose child has constipation or stool problems to start a bowel program. It is harder to convince those whose child does not have obvious bowel problems to implement a bowel program. Remember, even if a child does not have obvious constipation, they may need to have frequent bowel movements in order to urinate better. We commonly treat children who only have urinary problems with a bowel program, because there are no

medications or procedures that will make a child urinate more often and completely empty the bladder. If he has frequent bowel movements (goal=2 poops a day), he will have to sit, take his time, and usually he will urinate better also. By virtue of controlling and regulating poops, we regulate the processes by which a child begins to understand her pelvic muscles and relaxes and empties well.

Super poopers=Super peeers

Bowel movements can be safely manipulated with diet and mild laxatives. Fiber, fruits, vegetables, and increasing fluid intake can help with constipation. Good luck changing your child's diet to one that results in pooping often. We know what picky eaters some children can be! Fiber is, however, becoming easier to give. Fiber now comes in wafers, cookies, and flavored drinks that are available at most pharmacies and health stores. Laxatives are usually required to get the results that are needed. If the laxatives are given in low doses for several months that result in two poops a day (soft and mushy), they are not harmful. Making the stool softer and having a bowel movement each day is not usually sufficient to improve potty habits. Diarrhea and weight loss are signs that too much laxative is being used. If your child develops diarrhea, just decrease the dose, but do not stop it. You should start low (example ½-1 tablespoon per day of Milk of Magnesia), and slowly increase until 2 stools each day is achieved. For older or larger children, several tablespoons per day may be required. It will take a few weeks to determine the appropriate dose for your child. Parents should plan on their child taking the laxative for several weeks, or even months. There is no preferred laxative. Some taste better and are easier to give. Most laxatives do not require a prescription. Laxatives come in powders, liquids, pills, and chewables. Common examples include Miralax™, Senokot®, Lactulose, mineral oil, and Milk of Magnesia.

CHAPTER 13

MEDICAL TREATMENTS FOR CHILDREN WITH URINE AND BOWEL PROBLEMS

MEDICATIONS FOR CHILDREN WITH URINE PROBLEMS

URINARY FREQUENCY

Medications that relax the bladder are used to decrease urinary frequency. Medications for the "overactive bladder" do exist, and these are commonly prescribed in adults. These medications are effective in some children, but without addressing the underlying problem of abnormal potty habits, they will most likely be unsuccessful in treating your child's problem. The drugs have a common side effect of causing constipation. Constipation, as stated earlier, must be avoided when attempting to establish good potty habits. Some of these drugs are expensive. Parents tend to avoid working on the potty habits while waiting to see if the medication works. It is always important to make sure your child continues with good bathroom habits even when using these medications. The most commonly used medications are oxybutynin (Ditropan®, Oxytrol™), tolterodine (Detrol®), and hyoscyamine (Levsin®). Hopefully, you will elect to work on the potty habits prior to initiating the use of these medications.

URINARY URGENCY

The medications that relax the bladder and avoid spasms in adults can also be used in children with urinary urgency. These medications may give the child more of a gradual warning, prior to the sudden urge to pee. These medications are also commonly used in adults with urinary incontinence and frequency, but their routine use for these reasons in children should be discouraged. The most

commonly used drugs are oxybutynin (Ditropan®, Oxytrol™), tolteridine (Detrol®), and hyoscyamine (Levsin®).

The problem of holding urine until the last moment and the development of a thickened and muscular bladder will not be corrected with these medications. Only restructuring the child's daily potty habits will correct the root of the problem. In other words, these medications may treat the symptom, but not the problem. On occasion, I will use these medications in children with severe urgency, while aggressively addressing their total potty habit problems. If these medications are used, they should only be prescribed for several weeks until the rest of the potty problems begin improving.

DAYTIME ACCIDENTS

Medications are used to try and relax the bladder and give children more of a warning of oncoming urination. This provides them additional time to get to the restroom. Initially, medications may improve daytime accidents (incontinence), because they do relax the bladder. Unfortunately, accidents will continue if the holding and abnormal bladder and bowel habits are not improved. These medications are the same that adults use for the "overactive bladder." Oxybutinin (Ditropan®, Oxytrol™), tolterodine (Detrol®) and hyocyamine (Levsin®) are the more commonly used drugs for this purpose. These medications can have side effects that are problematic, namely constipation. Their routine, long-term use should be discouraged. I do not particularly recommend using these medications due to their side effects, and because parents will rely on the medication and simply avoid addressing the real problem of correcting the abnormal potty habits.

BEDWETTING

Bladder spasm medicine and those that affect bladder functions have also been used to treat bedwetting. Some medications relax the bladder, [oxybutynin (Ditropan®, Oxytrol®), hyoscyamine (Levsin®), tolterodine (Detrol®)], and others affect bladder and

sphincter functions, [imipramine (Tofranil®)]. These medications are commonly used for bedwetting, but usually result in only limited success.

The drug desmopressin (DDAVP®) is thought to be the ideal bedwetting drug, since it is a hormone that decreases nighttime urine production. Since it has not been proven that all children with bedwetting make too much urine at night, the results are unpredictable and mixed. This medication is expensive but is relatively safe. However, there are a few possible side effects. Recently it has been made available in a pill form (it used to be only available as a nose spray that required refrigeration). If a child is going to get good results from DDAVP®, they will usually know after just a few doses. In my opinion, the medication should not be taken long term. Children with larger bladders are more likely to be dry when taking DDAVP®. In most cases, it is not the "magic pill," and I strongly encourage parents to continue addressing the daytime potty habits even when their children are taking this medication.

MEDICATIONS/LAXATIVES FOR CHILDREN WITH BOWEL PROBLEMS

The various medications and methods for emptying the large intestine (colon) and rectum, and keeping them empty are discussed below.

1) **Enemas:** Enemas are liquids that are pushed into the rectum. Enemas can be 'homemade' or purchased at a pharmacy. Plastic tubes or bottles containing the enema fluid are inserted into the rectum. The fluid is then pushed in. The liquid softens the stool in the rectum and stretches the rectum, causing an urge to have a bowel movement. Usually the enema fluid contains an ingredient

that holds or draws water from the intestine, or it causes a mild irritation of the intestine. There are several types of enemas.

Fleet® and Fleet® Enema for Children: Contains water and sodium phosphate.

Soapsuds: Contains soapy water. The soap is mildly irritating and stimulates the intestine to secrete water.

Tap Water: An enema consisting only of tap water.

2) **Suppositories:** A suppository irritates the rectum, causing it to contract (squeeze) and push out a bowel movement. Commonly used suppositories include:

Glycerine
Bisacodyl (Dulcolax®)
BabyLax®

3) **Powerful Laxatives:** Laxatives are substances that are taken by mouth or go into the stomach to soften bowel movements and cause frequent stools. Most laxatives are effective in correcting constipation if the correct dosage is used. Laxatives most commonly work by keeping water in the intestine, thus making bowel movements very soft. Powerful laxatives are used to vigorously clean out the entire digestive tract, especially the colon and rectum. The most common powerful laxatives include:

Magnesium Citrate	GoLYTELY®
Fleet's Phospho Soda®	NuLYTELY®
Colyte®	

4) **Over-the-Counter (OTC) Laxatives:** Less powerful laxatives are used for routine constipation and to prevent future hard or large stools. There are many laxatives, and although their mechanism of action may be slightly different, their success is similar. OTC laxatives are available in liquids, chewables, pills, wafers and powders. Some are flavored and others are tasteless. Children do not usually enjoy taking laxatives, regardless of the form or taste.

Diarrhea, bloating, and cramps are common side effects of all laxatives. You may elect to allow your child to choose his laxative, but if your child is unable to easily choose a laxative he likes, then you may be forced to decide which laxative is best for him.

- MOM (Phillips' Milk of Magnesia®) and Citrate of Magnesia®: These laxatives contain magnesium salts that are poorly absorbed by the intestinal tract. As a result, the magnesium remains in the intestine along with a large amount of water. These draw water into the large intestine for easier passage of stool.

- Metamucil®, Citrucel®, Konsyl®, Konsyl® for Kids, Fibercon®, Serutan® Fiberall®, and Maltsupex®: These are all fiber-based, bulk-forming products that are taken with water. Fiber laxatives contain complex sugars that are not digested or absorbed in the intestine. They keep water in the intestine and make the stool softer.

- Mineral Oil: Mineral oil is non-absorbable lubricating oil that is digested by bacteria living in the large intestines. By-products from this digestion stimulate the intestine to secrete salt and water, resulting in more water in the intestine. Mineral oil has been used safely in young children, but a physician should supervise its use in children under the age of three.

- Senokot®, Senokot® Child, Fletcher's Castoria®, Ex-Lax®, XPrep®, Aloe Vera: These laxatives contain a natural plant derivative called senna. Senna stimulates the intestine and causes rhythmic muscle contractions, which then causes the lower intestine to contract and empty stool. Senna also stimulates the intestine to secrete salt and water.

5) Prescription Oral Laxatives: Some laxatives require a physician's prescription. These laxatives are not necessarily stronger,

more effective, or more dangerous. However, use of them does require a doctor's supervision.

- Polyethylene Glycol 3350 (Miralax™, GoLYTYELY®, Colyte®, NuLYTELY®, PEG-3350® with Electrolytes): These laxatives contain large molecules of ethylene glycol. Because the molecules are so large, the intestinal tract does not absorb them. The large molecules remain in the intestinal tract and keep water with them, causing the lower intestine to contract and empty stool. The major advantage of Miralax ™ is that it is 'odorless and tasteless,' and it can be mixed into juices and other fluids.

- Lactulose (Chronulac®, Duphalax®, Enulose®, Cepulac® and Constulose®): These laxatives contain sugar that is not absorbed by the intestinal tract. As a result, the sugar (lactulose) remains in the intestine, drawing water out with it. This keeps the stool soft and moves it quickly through the intestines.

6) Other commonly used brand name oral laxatives:

Alophen ®
Bisac-Evac ®
Carter's Little Pills ®
Citrucel ® Orange Flavor
Colace ®
Correctol ®
Correctol ® Stool Softener
DC-240 ® Softgels
Dulcolax ®
Evac-U-Gen ®

Fiberall ®
Fibercon ® Caplets
Fiber-Lax ®
Mylanta ® Natural Fiber
Nature's Remedy ®
Perdiem ®
Peri-Colace ®
Phillips' ® Concentrated
Senolax ® Sulfolax

My recommendation for laxative use is typically more aggressive than that of many other specialists. Children with constipation problems typically need an aggressive initial treatment with a

laxative. Once the bowels are cleaned out, they need to stay empty. I usually recommend that a laxative be used for several months following the initial constipation episode. As long as the dose is small, it should be harmless. If parents' only desire is to 'get the child going,' then the child is more likely to have future bowel and bladder problems. However, if parents concentrate on an on-going bowel routine and consistent potty habit routine, which allows the colon to shrink and regain its normal size, it is less likely that the child will experience routine bouts of constipation in the future.

My routine treatment requires a dose of laxative be given that results in two to three bowel movements each day. Stools with the consistency of rotten bananas are ideal when trying to get your child to go often. Diarrhea and cramps are signs that too much laxative is being given. Once a routine of going often (super pooper) is established, it is relatively easy to continue the dosage without side effects. I do not usually care which laxative is used, as long as the child and parent are compliant. If ill effects are encountered, then a different dose or type of laxative should be used. At the completion of two to four months of laxative use, I usually encourage the parents to stop the laxative but keep it close by in case they need to restart it. In other words, since constipation usually develops from certain personality types and lifestyles, the parents may find themselves treating the problem for years to come. Children with recurrent episodes of severe constipation should take a low-dose laxative for at least six months. Your child's doctor should be consulted prior to embarking on long-term laxative use.

CHAPTER 14

ADDITIONAL TOOLS TO HELP WITH BLADDER AND BOWEL PROBLEMS

PROGRAM HELPERS

The basic program outlined above is usually sufficient to correct routine bladder and bowel problems in children. Many times additional help is needed from devices and products that assure your child will follow the program and achieve success. Listed below are some of the more common items parents may want to consider when attempting to improve their child's potty habits.

Reward systems are helpful, especially for the younger children. As stated previously, praise from everyone is important. The child needs to know that good potty behavior is rewarded with praise and satisfaction. Stickers, small items, toys, and even candy are commonly used to reward good potty behavior. I am not a big fan of toys and candy, since they tend to become bribes instead of rewards. Calendars or charts that allow stickers to be displayed when a child performs well are excellent tools to track progress and show success. Calendars or diaries with stickers or comments work very

well, since they promote consistent and daily feedback and also serve as parental reminders to stay with the program. Regardless of the system or items used, the rewards should be simple and

103

achievable. The rewards should also be directly related to good potty behavior and not linked to other issues or problems. If the rewards do not seem effective, then make the reward be something the parents continue to control, like watching a favorite program or playing with a special toy. This allows the parents to recapture the reward and offer it again the next time the child performs the expected duty.

Bathroom timers provide children a visual or audible feedback on how long they should stay in the restroom. Remember, children like to take pit stops and not take their time when using the restroom. Timers that have the children sit on the potty for at least 3 minutes can be very valuable. Eventually your child will learn to take her time without your supervision. Bathroom timers help establish a habit of relaxing and not wanting to rush the bathroom process. Preferably, the timer should not be easy for the child to manipulate and speed up the restroom visit.

Watches with automatic reminders are excellent tools to keep children on a potty schedule. These watches are especially helpful during the day, when the parents are not present or when they are having difficulty reminding their child to go to the bathroom often. Depending on a child's schedule, the watch timers should be set to alarm or vibrate at every 1½ to 2 hours. Special watches with auto reset timers are ideal. The watch can be set to repetitively alarm at set intervals without requiring reprogramming. The watch will sound or vibrate and then start to automatically countdown again. This countdown will repeat throughout the day until the timer is stopped by the parent at nighttime. Younger children usually enjoy the watch and do not mind an alarm. Teachers and parents who hear the alarm should also instruct the child to go potty. Older children may be embarrassed by an alarm and desire a watch that vibrates. Vibrating watches provide more options, but they are usually more expensive and larger than watches that sound an alarm. These watches require that the child respond to the reminder and not ignore it.

Watches With Automatic Reminders Are Very Successful In Keeping Children On Track

Voiding and bowel diaries are useful when the parents are trying to monitor how often a child is peeing and pooping. Many times, the parents are not completely aware of what their child is doing while at school and away from home. By keeping a diary, parents can see if a child tends to have more problems during specific times of the day, at particular places, or during certain activities. Diaries are only helpful if they are accurate and kept for several days. The most informative diaries record the exact amount of urine, when and if urine or stool accidents occur, the time intervals between bowel movements, and the consistency of the stool. Keeping an accurate diary may require obtaining a urine collection device, measuring the amounts, recording the details, and observing the stool. Simple homemade charts suffice, but specially designed diaries can be obtained and are sometimes more informative. Your child's doctor can use this information to better understand your child's problem.

SAMPLE BLADDER AND BOWEL DIARY
Child's Name

Date

Time	Urine (√)	Stool (√)	Accident (y/n)	Comments

Urine collection devices can be obtained from a medical supply company or a physician. These open containers fit into the commode and collect the urine. A child, parent, or care provider can then measure and see how much urine is produced with each trip to the potty. If a small amount of urine is present, then the child is probably not completely emptying. By monitoring the amount of urine, the parent and child team can work together to eliminate more urine with each potty trip. These collection devices provide valuable and visual feedback for the child, while allowing the parents to monitor the child's ability to effectively empty the bladder. The amount of urine collected per potty trip should increase as the child's potty habits begin improving.

Counseling and support of others may be necessary to correct a child's problem and get them willing to participate as a team in the treatment process. Difficult bladder and bowel problems may not be easily overcome, and it takes the cooperation of everyone close to the child to achieve success. Often the parents are hesitant to discuss their child's problem with others. The parents and other loved ones will need to maintain an open dialogue to assure the child and those close to the child understand the problem and the expectations. Schools may need to be informed of the problem so they are understanding and supportive of your treatment plan. Your child will need to be reassured that you will not punish them if they have problems during the course of treatment. This, of course, is not always easy, especially if your child is not improving quickly and you begin to feel frustration. If you as the parent or your child are having significant difficulties addressing this problem, then it is advisable to seek outside help.

Your child's doctor or a professional counselor may be excellent resources for resolving any psychological issues your child may have. Since certain personality types and lifestyles can make a child susceptible to developing potty problems, the importance of counseling should not be overlooked. You cannot change your child's personality, and it is difficult to change their lifestyle, so

counseling can prove valuable when trying to understand these issues. Counseling should also be considered when other therapeutic strategies have failed. It is often important to improve your child's self-esteem and lower parental distress in order to correct the problem. Professionals who are very knowledgeable about the diagnoses and treatments of these problems can provide significant insight and help parents understand their child's situation. Professional counseling is very important when psychological problems exist that affect the day-to-day life of a child. Children who have experienced divorce, death, a new sibling, peer problems, or a new school can have issues that significantly influence their ability to maintain normal bladder and bowel functions. Pychological counselors, family physicians, pediatricians, and school counselors can be helpful in identifying or discussing these issues. Once the issues are known, then children are more likely to get the comfort and attention they deserve in order to better deal with their concerns.

CHAPTER 15

SETBACKS AND FAILURES

The most common cause for unsuccessful treatment of bladder or bowel problems is parental compliance. It is very difficult to constantly monitor and enforce good bathroom habits. Parents and families need to understand that these problems may take significant time to correct. In most cases, sticking with the program is a marathon, not a sprint. Staying with a program long term and making sure others (teachers, babysitters, and grandparents) continue to enforce your guidelines will ensure success. If your child's program is difficult to enforce, consider obtaining a watch for timed bathroom breaks and setting a timer in the restroom to make sure your child relaxes and takes his time. These additional tools may be very helpful in assuring continual compliance with frequent and unhurried bathroom visits. Remember, you are trying to overcome traits that are inherent with your child's personality and lifestyle, and this may not be an easy task to achieve.

Another common cause for difficulties is the failure to work on both urine and stool habits simultaneously, regardless of the problem. It is very common for parents and care providers to not link bladder and bowel functions together. Parents and physicians tend to focus on the specific urine or stool problem without considering all of the bladder and bowel functions. It is critical for children to understand that using the restroom often for all bodily functions is important. Going often to urinate will help with constipation and vice versa. It must be emphasized that most children develop problems from holding or hurrying. Children that tighten their bottom muscles (sphincters) and hold their stool are most likely to hold their urine, even if they do not have any obvious urine problems. The reverse is also common; children who hold their urine are also more likely to hold their stool. Children who fail

to correct their potty habit problems often have either urine or stool issues that have not been addressed. I cannot stress this relationship between urine and bowel problems enough.

Confusion on both the part of the parents and child can cause the treatment plan to fail. Advice is commonly provided by everyone in contact with the child. If the child's doctor, teacher and family members all provide conflicting advice on how to best correct the problem, then the treatment or program will not be consistent and will likely fail. You should stay the course and not deviate if you feel comfortable with the advice in this book or with what others are telling you. Children with bladder or bowel problems need consistency and structured approaches; otherwise they will gravitate toward the easiest or least involved approach, which will not ultimately correct the problem.

The misconceptions that laxatives are harmful when taken in larger doses or for longer periods of time will also commonly interfere with successful treatment. Many parents, and some physicians, are hesitant to use laxatives at a high enough dose to get the results that are needed. Also, there are strong misunderstandings about the safety of long-term laxative use. Both of these issues tend to cause a child to be under treated. If the bowel program is not addressed in an aggressive fashion, then it is common for the child to have relapses, especially if constipation is a problem. Remember, your child's potty problems did not develop overnight. It will take time to recondition the intestine and develop long term improvement in your child's habits. If the short-term goal is to have normal bowel movements, then the lower doses of laxatives for shorter periods of time may suffice. However, if the goal is to have frequent, soft bowel movements and correct all of your child's abnormal potty habits, then a more aggressive bowel program (even for several months) is advisable to more successfully establish normal intestinal function and instill good long-term potty habits.

Lastly, do not forget about the power of reward and praise. Children respond well to encouragement. Reward and praise should be used to encourage adherence to diet, toileting routines, and for taking laxatives/medications. Reassurance, consistency, and understanding will foster success more than all other approaches. Parents, and others close to the child, should act as a team. They should all work together to give the child the best encouragement to succeed. If your child does not gain a sense of self accomplishment, or if confusion and manipulation prevail, then recovery is likely to be delayed. Praise, love, and hug your child while continuing to instill the best potty habits ever. Your goal is to make your child have better urine and stool habits than the average child.

The most common causes for setbacks/failures include:
- Child and parent non-compliance
- Failure to link bladder and bowel functions
- Inconsistent treatment approaches
- Unwillingness to use laxatives to their fullest potential
- Failure to provide continual encouragement

CHAPTER 16

SUMMARY

Having read this book, you are now an expert about almost all issues related to abnormal potty habits in children. Even with an excellent understanding of what your child is doing to cause her abnormal potty habits; you may not be able to easily correct the problem. The advice given in this book sounds easy, but it can be difficult to follow on a daily basis for weeks, and months, and even years. Once you have achieved success, the rewards are worth it, and your child will live a happier and healthier life. Because of your hard work, your child will succeed. While you may become frustrated, please remind yourself that you are not alone. Millions of parents have experienced similar problems with their children's urine and bowel problems. You will be one of the many PottyMD success stories if you gain the support of others and follow the advice in this book. The program, diet, and ideas that are presented in this book will help you and your child immensely. Our goal is to spare a child the embarrassment, unnecessary medical testing, and long-term problems that can result from abnormal potty habits.

> With a *firm* and *loving* approach, your success is just around the corner, down the hall, and in the bathroom.

ADDENDUM A

FIBER CALCULATIONS

*Approximate fiber measurements—each brand may differ

Fruits	Serving	Fiber (gm)
Apple with skin	1 medium	3.7
Apple without skin	1 med	2.4
Applesauce	½ cup	2.0
Apricots	3 med	2.5
Banana	1 med	2.7
Blueberries	1 cup	4.0
Cantaloupe	1 cup	1.3
Cherries	10 cherries	1.3
Fruit salad	½ cup	1.3
Grapefruit	½ med	1.3
Grapes	1 cup	1.2
Honeydew melon	1 cup	1.0
Mandarin oranges	½ cup	1.0
Nectarine	1 med	2.2
Orange	1 med	3.0
Peach	1 med	1.7
Pear	1 med	4.0
Pineapple	1 cup	2.0
Plum	1 med	1.0
Prunes	10 prunes	6.0
Raisins	2/3 cup	4.0
Raspberries	1 cup	8.4
Strawberries	1 cup	3.4
Tangerine	1 med	2.0
Watermelon	1 cup	0.8

Vegetables	Serving	Fiber (gm)
Artichoke	1 med	6
Asparagus	½ cup	1.4
Baked beans	1cup	14.0
Broccoli	½ cup	2.3
Brussels sprouts	½ cup	2.0
Carrots	1 med	2.0
Cauliflower	½ cup	1.7

115

Celery	1 stalk	0.7
Coleslaw	½ cup	1.0
Corn	½ cup	1.5
Corn on the cob	1 ear	2.0
Cucumber	½ cup	0.5
Eggplant	½ cup	1.0
Green beans	½ cup	2.0
Kidney beans	½ cup	4.5
Lima beans	1 cup	13.2
Lettuce	½ cup	0.5
Mushrooms	½ cup	0.4
Olives (green or black)	6 pcs	1.2
Onions	½ cup	1.0
Peas	½ cup	4.0
Pinto beans	1 cup	14.7
Potato, baked with skin	1 med	5.0
Potato, boiled	1 med	2.0
Potato salad	½ cup	1.6
Pumpkin	½ cup	5.0
Spinach, boiled	½ cup	2.2
Spinach, raw	½ cup	0.8
Squash	½ cup	3.0
Sweet potato	1 med	3.0
Tomato, raw	1 med	1.0
Zucchini	½ cup	3.0

Cereals	Serving	Fiber (gm)
All-bran, Kellogg's	½ cup	10.0
Alpha-Bits	1 cup	1.0
Banana Nut Crunch	1 cup	4.0
Bran Buds, Kellogg's	1/3 cup	12.0
Cheerios	1 cup	3.0
Chex Morning Mix Fruit & Nut, General Mills	1 pouch	1.0
Corn Flakes, Kellogg's	1 cup	1.0
Corn Pop	1 cup	0.0
Cracklin' Oat Bran, Kellogg's	¾ cup	5.6
Cream of Wheat	1 pack	1.0
Crispix, Kellogg's	1 cup	<1.0
Eggo Minis, Kellogg's	3 waffles	2.0
Fiber One, General Mills	½ cup	13.0
Frosted Mini-Wheats	5 biscuits	5.0

Honey Nut Cheerios	1 cup	2.0
Honey-Comb, Post	1 1/3 cup	<1.0
Instant Oatmeal	1 pack	3.0
Kix, General Mills	1 1/3 cup	1.0
Life, Quaker	½ cup	1.0
Lucky Charms, General Mills	1 cup	1.0
Multi-grain Cheerios	1 cup	3.0
Nutri-Grain Bars (Raspberry), Kellogg's	1 bar	1.0
Pop-Tarts (blueberry), Kellogg's 1 pastry	1.0	
Quaker Shredded Wheat	3 biscuits	7.3
Quaker Squares	1 cup	5.0
Raisin Bran, General Mills	¾ cup	3.0
Raisin Bran, Kellogg's	1 cup	8.2
Special K Red Berries, Kellogg's 1 cup	1.0	
Trix, General Mills	1 cup	1.0
Wheaties, General Mills	1 cup	3.0

Breads/Grains	Serving	Fiber (gm)
Bagel	1 bagel	1.5
English Muffin, Thomas	1 muffin	1.5
French bread	1 slice	0.5
Italian, Bakery Light	1 slice	2.5
Multi-grain	1 slice	1.5
Pancakes	1 med-large	1.0
Pita, white	1 6 inch	1.0
Seven grain, Bran'ola	1 slice	3.0
Tortillas	2	4.0
Wheat, Bakery Light	1 slice	2.5
White	1 slice	1.0
Whole wheat	1 slice	2.0

Pasta	Serving	Fiber (gm)
Elbow macaroni, Golden Grain	½ cup	2.0
Macaroni	1 cup	1.8
Macaroni, whole wheat	1 cup	4.0
Spaghetti, whole wheat	1 cup	6.3
Brown rice, long grain	1 cup	3.5
White rice	1 cup	1.0

Other Common Foods	Serving	Fiber (gm)
Peanut butter	1 tbsp	1.1

Peanuts (dry roasted)	1 tbsp	1.1
Popcorn	1 cup	1.0
Wheat thins, Nabisco	6 pcs	2.2
Triscuits, Nabisco	2 pcs	2.0
Graham Crackers	2 pcs	0.4

Burger King

Hamburger/Double Hamburger/Cheeseburger		1.0
Double Cheeseburger		2.0
Chicken Tenders (4 pc.)	0.0	
Chicken Tenders (6 pc.)	<1.0	
Small French Fries		2.0
Large Onion Rings		5.0

McDonald's

Mighty Kids Meal:	3.0
(6pc. McNuggets, fries, drink)	
Mighty Kids Meal:	4.0
(Double Hamburger/Cheeseburger, fries, drink)	
*Same Fiber Content for Happy Meals	
Large French Fries	6.0
Fiesta Salad	5.0

Wendy's

Kid's Meal French Fries	4.0	
Junior Hamburger/Cheeseburger		2.0
Spring Mix Salad		5.0
Chicken Nuggets		0.0

ADDENDUM B

CHILD FRIENDLY RECIPES FOR CONSTIPATION

Breakfast

Raisin Breakfast Bars
¾ cup of all-purpose flour
¾-cup granola or toasted wheat germ
¼ cup of sugar
½ teaspoon baking power
½ teaspoon cinnamon
¼ cup butter (melted)
¼ cup honey
1 egg
½ teaspoon vanilla
½ cup of golden raisins

Preheat oven to 350°. Grease an 8-inch square pan. Combine flour, granola, sugar, baking powder and cinnamon. Stir in butter, honey, egg and vanilla; mix well. Stir in raisins. Press mixture into greased pan. Bake for 20-25 minutes or until lightly browned. Cool. Remove bars and wrap individually in plastic.

Oatmeal-Chocolate Chip Bars
½ cup butter flavored Crisco
½ cup firmly packed brown sugar
1 egg
1 teaspoon vanilla extract
½ cup all purpose flour
½ teaspoon baking soda
½ teaspoon salt
1 ¼ cup old-fashioned rolled oats
1 package of milk chocolate chips

Preheat oven to 350°. Mix Crisco and brown sugar. Add egg and vanilla. Stir in flour, soda and salt. Fold in rolled oats and milk chocolate chips. Spoon onto greased cookie sheet. Bake 8-10min. Cool on wire rack.

Yogurt
Your favorite yogurt (with or without fruit)
¼ cup Granola and raisins

Mix well and dig in.

French Toast Treat
2 Frozen French toast
1 egg
½ cup frosted shredded wheat (crushed)
¼ teaspoon cinnamon
Beat egg. Mix cinnamon and shredded wheat together. Roll toast in egg and sprinkle wheat mix over toast. Bake in oven or toaster oven for 8-10 minutes. Serve with syrup. Yummy!

French Toast Kabobs
1-2 Frozen French toast
2-3 whole strawberries
Several blueberries
Skewers (used with adult supervision)

Powdered sugar
Syrup

Make French toast. Slice into sections, cut fruit into chunks, and arrange on skewer. Arrange on plate, drizzle with syrup and sprinkle with powdered sugar.

Cereal Add Ins
Your kid's favorite cereal
¼ cup of bran cereal
Milk

Mix both cereals together. Add milk. Enjoy!

Apple Treats
1-2 apples
Honey or syrup

Slice unpeeled apples and warm in the microwave or oven. Drizzle warm fruit with syrup or honey. Your kids will love it.

Bran and Raisin Pancakes
¾ cup all-purpose flour
2 tablespoons sugar
1 tablespoon baking powder
½ teaspoon salt
1egg, slightly beaten
1 ¼ cup milk

1 cup bran cereal
¼ cup raisins
3 tablespoons margarine, melted divided

In a large bowl, mix flour, sugar, baking powder and salt. Mix egg, cereal, and 2 tablespoons of margarine. Set aside for 1-2 minutes until liquid is absorbed. Stir mixture. Add flour mixture to cereal mix, and stir until moistened. Stir in raisins. Batter will be lumpy. Heat remaining margarine in a frying pan over medium heat. Drop batter into hot skillet. Cook until bubbling on top, flip and cook about 3 more minutes.

Applesauce Cranraisin Muffins
¾ cup all-purpose flour
½ cup whole-wheat flour
½ cup sugar
1 tablespoon baking powder
½ teaspoon baking soda
¼ teaspoon salt
1 teaspoon cinnamon
2 cups of your favorite bran cereal
1 ½ cups applesauce
¼ cup milk
3 eggs
½ cup of cranraisins

Mix together flour, sugar, baking powder, soda, salt and cinnamon. In a separate bowl, mix cereal, applesauce and milk. Set aside for 5-6 minutes to allow the cereal to soften. Add eggs and beat well. Add raisins and flour mixture. Stir just enough to combine ingredients. Pour into 2 ½ inch muffin pan coated with cooking spray. Bake at 400° for 20 minutes or until lightly browned. Serve warm.

Breakfast Cobbler
½ teaspoon of lemon juice

8 apples sliced in small sections (do not remove the peeling)
1 ½ cup granola cereal with fruit and nuts
1 ½ cups of sugar
Dash of cinnamon
¾ cup melted butter

Place apples in lightly oiled slow cooker. Add sugar and lemon, mix. Combine cereal with butter and add to cooker. Cook covered on low 6-8 hours or overnight. Serve hot with vanilla yogurt.

Blueberry Oatmeal Muffins

4 tbsp. sugar

4 tbsp. melted butter

1large egg

1 cup blueberries

1 cup of milk

2 cup Bisquick

Topping:

¾ cup of rolled oats

sugar

½ tsp. nutmeg

optional almond slices

Mix all ingredients together with spoon, being careful not to over mix. Fill greased muffin pan and sprinkle on topping. Bake at 400° for 15 minutes. Makes 12 large muffins.

Entrees and Side Dishes

Whole Wheat Crust

1 package of yeast
1 teaspoon sugar
½ cup water
1 cup all-purpose flour
½ cup whole-wheat flour
¾ teaspoon salt
2 teaspoon olive oil

Stir yeast and sugar into warm water and let stand until foamy. Mix flours and salt in separate bowl. Create a well in the center; add yeast mixture and mix until dough begins pulling away from side of

bowl. Add oil. If dough sticks, add additional all-purpose flour one tablespoon at a time until dough leaves side of bowl. Place dough in oiled bowl, turning once to coat. Cover and let rest in warm, draft-free area until doubled in size; about 1 ½ hours. When ready, roll out into pizza shape and top with favorite topping. Bake in 425°oven for about 20 minutes.

Kid Cheese Quesadillas
Whole- wheat bread or
 Whole-wheat pita pockets or tortillas
¼ cheddar cheese
Corn oil

Heat a small amount of oil in a skillet. Place bread or tortilla in oil and brown slightly. Turn over and add cheese, continue heating until cheese is melted. Fold or cut in half. Serve.

High Fiber Chili
½ pound of lean ground beef
½ pound of lean ground turkey
1cup of onions
½ cup of green pepper
1 cup of bran cereal
1 can of tomato sauce
1 can of diced tomatoes
1 can of kidney beans
½ cup of water
1 teaspoon of salt
2 tablespoons of chili powder
¼ teaspoon of garlic powder
1 bay leaf

In a 4-5 quart saucepan, cook beef, turkey, onion and green pepper. Stir frequently until meat is no longer pink. Drain off fat and liquid. Stir cereal and remaining ingredients into meat mixture. Bring to a

boil, stirring frequently. Cook one hour. Remove bay leaf before serving.

Hints: For veggie chili, omit beef and turkey. Add 1 can great northern beans. (15.5 oz).

High Fiber Burgers
2/3 cups bran cereal
½ cup finely chopped onion
2 tablespoons Worcestershire sauce
1 teaspoon garlic salt
1 egg
1 pound lean ground turkey

Mix all ingredients together except meat. Let stand 5 minutes to soften cereal. Gently fold in turkey. Shape into 4-inch patties. Grill, broil or pan fry until meat is thoroughly cooked. Serve hot on bun.

Hot Dog and Potato Dinner
2-3 (15oz.) cans whole potatoes (with skin on)
Or 3-4 unpeeled potatoes cut into squares and cooked
5-6 hotdogs sliced
4-5 eggs beaten with 5 tbsp. milk
Salt and pepper to taste
Butter for browning
1 small onion chopped finely (optional)

Cut canned potatoes into squares. In a large frying pan, brown potatoes in butter on medium heat. Add salt and pepper to taste. Add chopped onion and sliced hot dogs, browning slightly. Stir ingredients together. Add the egg mixture and stir to coat all the pieces. Continuously cook until cooked thoroughly. Serves 5.

Bran Chicken
1 ½ cup wheat bran flakes crushed
1 egg

¼ cup milk
¼ cup all- purpose flour
Dash of salt and pepper
1/8 teaspoon of sage
3 tablespoons grated Parmesan cheese
4 chicken pieces washed and patted dry. (1 to 1 ½ lbs.)
1 tablespoon butter, melted

Place cereal in a shallow bowl, set aside. In small mixing bowl, beat egg and milk slightly. Add flour, salt, sage and cheese, stirring until smooth. Place chicken pieces in egg mixture. Coat with cereal. Place in greased baking pan. Drizzle with margarine. Bake 350° for about 45 minutes. Do not cover or turn chicken while baking.

Casserole, Soup, or Salad Topping

2 tbsp. regular margarine or butter
1 cup Kellogg's® All-Bran® cereal
Melt margarine or butter in frypan and add cereal. Cook until slightly browned. Toss with seasoning (garlic salt, parmesan cheese,or Italian dressing). As it cools it will become crisp.

Snacks Kid Style

Puppy Chow
This is a great snack for kids. It is great for after school snacks and road trips.

3 tablespoons canola oil
¼ cup honey
2 cups Corn Chex cereal
2 cups of Rice Chex cereal
1 cup of mini pretzels
½ cup raisins
½ cup of M&M's

In a small bowl stir together oil and honey. In a large bowl stir together cereals and pretzels. Top with honey mixture, and stir until well combined. Microwave on high for 5-6 minutes, stirring every 60 seconds until cooked through. Cool completely. Add raisins and M&M's.

Workout Cookies
3 cups oatmeal
1 ½ cup brown sugar
1 ½ cup flour
1 ½ cup butter
1 ½ teaspoon baking powder

Dump all ingredients in large bowl. Mash it! Knead it! Pound it! The longer and harder you mix it, the better it tastes. Roll dough into small balls in your hands. Bake on cookie sheet at 350° for 10-12 minutes.

Jell-O Blocks
¼ cup applesauce
¼ cup apple juice
2 tbsp. psyllium powder or Metamucil

1 small pkg. Jell-O
1 cup hot and cold water

Gel in refrigerator and cut into blocks. Lasts 2-3 days in refrigerator if covered.

Zip Corn
1 cup popped corn
1 tbsp shelled sunflower seeds
1 tbsp. Parmesan cheese
1 tbsp. wheat germ
1 tbsp. raisins

Combine all ingredients into zip lock bag. Zip. Eat and enjoy.

Animal Crackers
½ cup of oatmeal
2 teaspoons of honey
¼ to 1/8 teaspoon of salt
¾ cup of flour
¼ cup of baking soda
¼ cup of butter
4 tablespoon of buttermilk

Preheat oven to 400°F. Grind oatmeal in a food processor until fine like a powder. Put in a large mixing bowl. Add honey, salt, flour, soda, and stir. Cut in butter. Add buttermilk and stir until a well-mixed ball forms. Roll dough out thinly on floured surface. Cut with animal cookie cutters and bake until light brown. 8-10 minutes.

Frozen Hawaiian Tropical Drink
¼ cup low-fat milk
¾ cup pineapple juice
½ tsp. coconut extract/flavoring
1 tbsp. orange flavored smooth psyllium powder

Mix all ingredients in a blender with ice. Add 1 tsp. sugar or to taste.

Yogurt Parfaits
16-ozs carton lemon or vanilla yogurt
¼ cup fruit of your choice
¼ cup of grapenuts

Sprinkle grapenuts on bottom of parfait bowls spoon in yogurt to half way. Add fruit and top with more yogurts. Sprinkle with remaining grapenuts. Yummy!!

Sandwich Surprises
Peanut butter
1-2 slices of whole wheat bread
Your favorite toppings (ex. Granola, apples, raisins etc…)

Spread peanut butter on toasted bread.
Top with your favorite topping and eat ☺

Orange Freeze
½ cup frozen orange-juice concentrates
1 cup plain yogurt
1 teaspoon sugar, optional
4-5 ice cubes

Place all ingredients in a blender and blend. Top with sprinkle and serve.

Bugs on a Log
Make "logs" from any of the following:
Celery stalks (cut about 3 inches long)
Apples (cut in half or quarters with cores removed)
Carrots sticks (cut to about 3 inches long)

Cover logs with peanut butter--then sprinkle "Bugs" on the logs:
Raisins
Unsweetened high fiber cereal
Sunflower seeds
Golden raisins

Hint: Add 1 tbsp. bran to foods. Slowly work up to 2 tbsp. daily. Put bran in cereal, mashed potatoes, pureed foods or combine with hamburger.

Warning: Infants and small children can easily choke on food. Monitor all children while eating. Food allergies are common. Some of these recipes and diet recommendations may not be appropriate for your child.

COMMONLY USED MEDICAL WORDS

Anal Retentive: A personality style described by the famous neurologist Sigmund Freud. This personality style usually is associated with extremes of personalities. Typically these individuals are very organized, structured, and controlling. People with this personality may be super-achievers or referred to as having a type A personality. It may be a temporary state, but usually these people are always intense, emotional, and at times, uptight. I am not throwing stones at these individuals, since I tend to be commonly placed in this classification myself. For the purposes of this book, children that are anal-retentive tend to have tight pelvic muscles and hold their urine and stool for longer periods of time than others. Their personality type causes them to be more focused and interested on other issues. They tend to develop constipation and other potty problems.

Anal Fissures: Cracks or tears in the anus. Anal fissures commonly occur with large or hard bowel movements. Anal fissures are common in children with constipation and they can be irritating, painful, and itchy.

Anus: The external part of the body where stool comes out.

Bowel Movement (BM): Voluntary and involuntary production of stool.

Bladder: The body organ that stores and empties urine. It is a muscular organ that stores urine under low pressure. The bladder's muscle contracts when it is instructed by the brain to empty.

Bladder Spasms: When the bladder has a sudden urge to empty. If a child has a neurological problem or an infection, there may be significant bladder contractions or spasms. In children with abnormal potty habits, the bladder is not able to fill and completely empty at normal intervals. In these children, the bladder muscle tends to get thicker and stronger because it attempts to empty against an abnormally tight sphincter. At times, the bladder will suddenly contract and try to empty, causing a spasm, without any other underlying abnormality. Bladder spasms result in stomach

cramps usually below the belly button, pelvic pain, or leakage of urine (incontinence).

Colon: The part of the large intestine between the cecum and the rectum. It extracts moisture from food residues before they are excreted.

Constipation: Infrequency of bowel movements, characterized by abnormally large, hard or painful stool. In a child with abnormal potty habits, constipation usually results from holding stool for long periods of time. Diet and fluid intake can also cause constipation. Well-rounded diets that include normal fluid and fiber intake could prevent constipation from occurring as long as a person does not hold and does not have an underlying medical problem. Constipation can result in belly pain, cramping, painful bowel movements, and even bowel accidents (encopresis). Anal tears, bleeding, and itching can also result from constipation. Fecal staining of the undergarments also hints that a child may have significant constipation.

Cystitis: An infection or inflammation of the bladder. The infections are usually bacterial (example E.Coli) and can result in significant urinary symptoms that include frequency, burning on urination, leakage, pelvic pain, and blood in the urine. Low-grade fevers may be associated with cystitis but these fevers are usually not greater than 101°.

Diarrhea: Frequent and watery bowel movements.

Diurnal Incontinence: Voluntary or involuntary loss of urine (wetting accidents) that occurs during the daytime. Nighttime wetting, or nocturnal enuresis, can be associated with diurnal incontinence. Any form of wetting accidents, either very small (moist underwear) or large, is referred to as diurnal incontinence. The child may be completely unaware or intentionally have urinary wetting accidents.

Dysfunctional Elimination Syndrome: Abnormal emptying of urine and/or stool (abnormal potty habits). Children with this problem tend to present with a wide variety of signs, symptoms, and complaints. These children commonly have problems with avoiding using the restroom, very frequently using the restroom, urgently

going, holding and squatting, abdominal pain, soiled or stained underwear, blood in the urine, constipation, and daytime or nighttime accidents of urine and or stool.

Dysfunctional Voiding: Children who have urinating problems without a medical explanation are referred to as having dysfunctional voiding. This medical term implies having abnormal urinating habits without having obvious problems with bowel movements. Now that bowel problems are known to commonly be associated with urinating problems, this term has been mostly replaced by dysfunctional elimination syndrome.

Dyssynergia: Urologists and Pediatric Urologists use this term to imply the conflicting actions of the bladder and rectum with the pelvic muscles. When the bladder or bowel tries to empty, and the pelvic muscles or sphincters do not relax, then there is a conflict. This results in pain, accidents, incomplete emptying, and any of the other complaints that are associated with abnormal potty habits.

Dysuria: Painful urination that is often described as burning or in a child's words having "needles" or "stinging". Dysuria is common in children with urinary tract infections, irritated private parts, and abnormal potty habits.

Encopresis: The condition of having bowel accidents. Constipation is commonly associated with encopresis.

Enuresis: The condition of having urinary accidents whether daytime or nighttime. Most people refer to nighttime wetting (nocturnal enuresis) as enuresis.

Feces: Stool or bowel movement.

Fecal Impaction: A severe form of constipation. This can result in the child's inability to have a bowel movement because the stool is too large or hard to pass.

Frequency: When a person uses the restroom often. Urinary frequency is one of the most common problems in children with abnormal potty habits.

Gastrocolic Reflex: A reflex that occurs following a meal that stimulates a bowel movement. When the stomach fills with food, it stimulates the colon to contract and encourages a bowel movement.

133

Gross Hematuria: To have blood in the urine that is visible. Gross hematuria usually implies some form of underlying problem such as stones, urinary tract infections, birth defects of the urinary system, and trauma.

Hematuria: Blood in the urine that is either visible or invisible.

Hesitancy: When one has a delay or difficulty starting a urinary stream.

Impaction: The term used for a stool that is too large or hard to pass (same as fecal impaction).

Incontinence: To leak urine or stool. Usually refers to leaking urine.

Interstitial Cystitis: A nonspecific condition of the bladder that usually occurs in adults. This disease is not easily diagnosed and the symptoms are very similar to children with dysfunctional voiding and elimination syndrome. I believe that children who grow up with uncorrected bad potty habits are likely to develop interstitial cystitis.

Kidney: The body organ that filters blood and makes urine. The kidney regulates toxins in our bloodstream, body water, blood production, and blood pressure.

Microscopic Hematuria: Blood in the urine that is not seen with the naked eye. Blood can be detected in the urine by using a microscope or performing a "dip stick" test.

Pediatric Gastroenterologist: A physician who has completed medical school, a pediatric residency, and a pediatric gastroenterology fellowship (pediatric GI). Pediatric residencies are typically 3-4 years and the fellowship is an additional 2-3 years. Pediatric gastroenterologists diagnose, manage, and treat children with swallowing, digestive, intestinal, and liver problems. The most common problems they treat are Crohn's Disease, gastroesophageal reflux, constipation, abdominal pain, and abnormal liver function.

Pediatric Nephrologist: A physician who has completed medical school, a pediatric residency, and a pediatric nephrology fellowship. The pediatric residency is usually 3-4 years. The pediatric nephrology fellowship is an additional 1-3 years. Pediatric nephrologists diagnose, manage, and treat children with problems

related to the urinary system. Most commonly they treat children with abnormal urine tests, kidney failure, and kidney transplants.

Pediatric Urologist: A physician who has completed medical school, a urology residency, and a pediatric urology fellowship. The urologic residency training is typically 5-6 years and includes 1-2 years of general surgery training. The pediatric urology fellowship is an additional 1-2 years. Pediatric urologists diagnose, treat, and manage problems related to the adrenal glands, kidneys, bladder, and urinary tract system including the ureters and urethra and private parts (genitalia) in children. The most common problems a pediatric urologist treats are blockages in the urinary tract, vesicoureteral reflux, urinary tract infections, birth defects involving the urinary system, undescended testicles, and genital abnormalities including intersex disorders. Abnormal potty habits (dysfunctional elimination syndrome) are some of the most common conditions that a pediatric urologist treats.

Pyelonephritis: An infection involving the kidney that is usually caused by bacteria. Children with pyelonephritis usually present with back pain, fever greater than 101°, and poor appetite to include nausea and vomiting.

Rectum: The final portion of lower colon that signals the urge to have a bowel movement. The rectum communicates with the anus to control the flow of stool to the outside world.

Sphincter: A muscle that wraps around the urethra and rectum. This muscle can tighten and hold urine in the bladder or stool in the colon. There are several sphincters. Some sphincters can be tightened and contracted by a child when they do not want to use the restroom. Sphincters are supposed to be relaxed and open when one pees or poops.

Stool: Solid excretory product from digested food that is evacuated from the bowels.

Stress Urinary Incontinence: To experience urinary leakage when coughing, laughing, or lifting. Children who leak with laughter are referred to as having "giggle incontinence".

Ureter: This is the very small tube that drains urine from the kidney as it empties into the bladder.

Urethra: This is the passageway from the bladder to the outside world. The urethra is a tube structure that is short in girls and longer in boys. The urinary sphincters and pelvic muscles wrap around the urethra and coordinate their activity with the bladder to either allow storage or emptying of urine.

Urge Urinary Incontinence: To have a sudden urge to use the restroom followed by urinary leakage. Children and parents will describe that they do not get to the restroom quick enough before having an accident.

Urgency: To have a sudden urge to urinate (and possibly have a bowel movement).

Urinary Tract Infection (UTI'S): Any infection involving the urinary tract, which most commonly is either kidney or bladder. Infections involving the ureters (kidney tubes) and urethra (bladder tube) are also considered urinary tract infections. Urinary tract infection is a very broad term. Many people will use the term UTI when explaining a pyelonephritis (kidney) or cystitis (bladder) infection.

Vesicoureteral Reflux (VUR): When urine abnormally backs up the kidney tubes (ureters) during bladder filling and/or emptying. Vesicoureteral reflux, commonly referred to as reflux, is diagnosed during a voiding cystourethrogram (VCUG). VUR is important in children with urinary tract infections.

Voiding: The act of urinating. The medical term of peeing.

Voiding Cystourethrogram (VCUG): An x-ray of the bladder and urethra. A tube (catheter) is inserted into the urethra and the bladder is filled with x-ray or nuclear "dye". X-rays of the bladder and urethra are taken during filling and emptying.

POTTYMD.COM
Home of the Potty Monkey™

Center of Excellence for:
Potty Training
Potty Problems After Training
Bedwetting
Constipation/Encopresis

Exclusive PottyMD Products

Potty Monkey™ Products
Calendar/Reward Systems
Tinkle Timers™

Urine/Bowel Monitoring Kit
Books (all topics)
Counseling

Other products available from PottyMD:

Bedwetting Alarms
Potties
Videos

Watches for Timed Voiding
Potty Seats
Waterproof Bedding

And Much, Much More!

pottymd.com

1-877-PottyMD